DOUBLE
TAKE

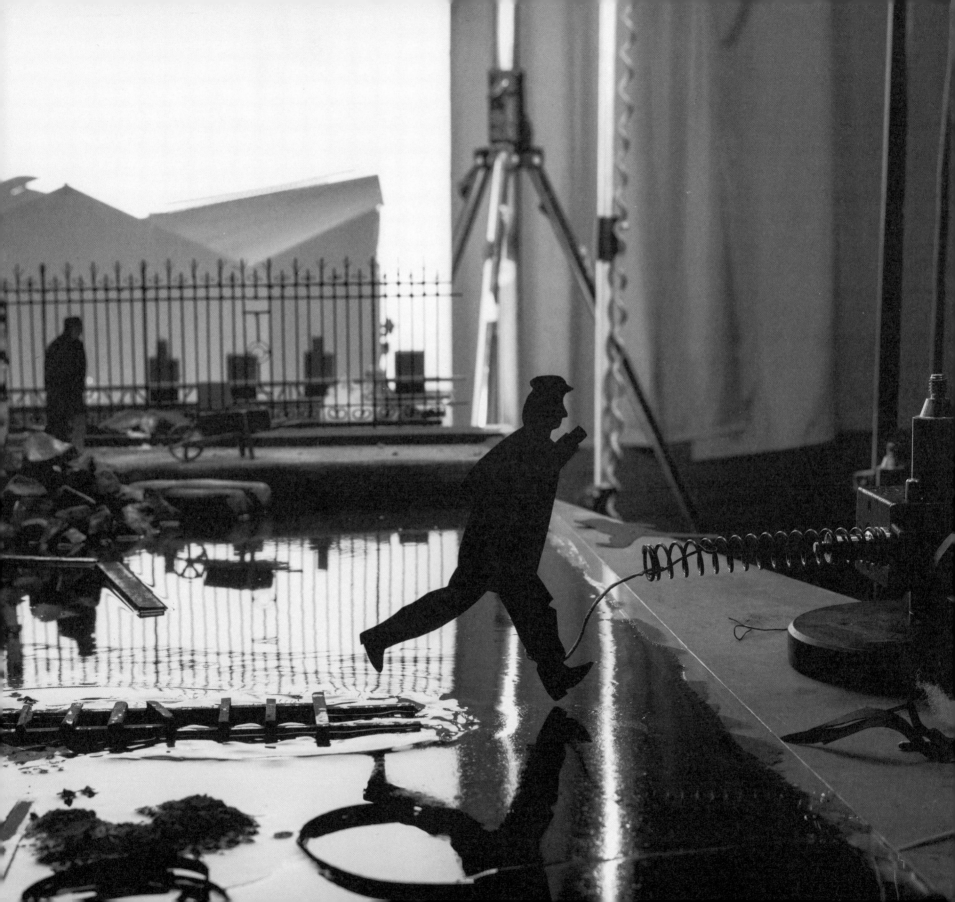

JOJAKIM CORTIS
ADRIAN SONDEREGGER

DOUBLE TAKE

THE WORLD'S MOST ICONIC PHOTOGRAPHS METICULOUSLY RE-CREATED IN MINIATURE

88 ILLUSTRATIONS

Thames & Hudson

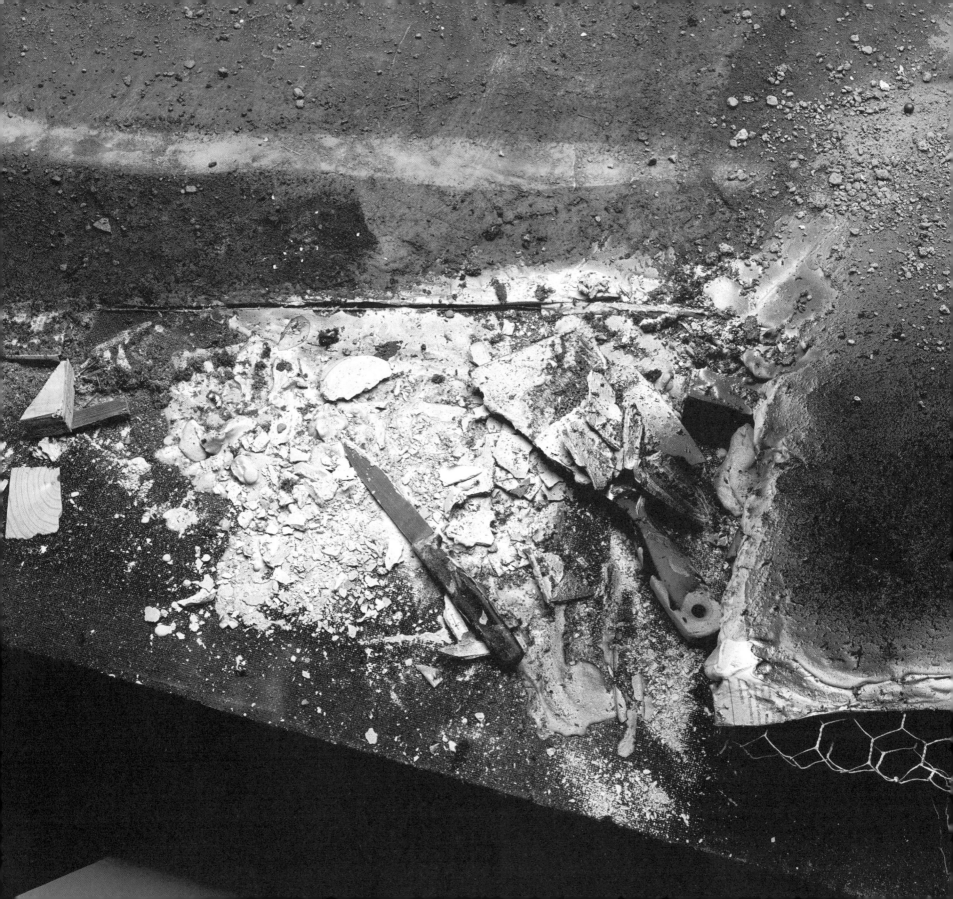

CONTENTS

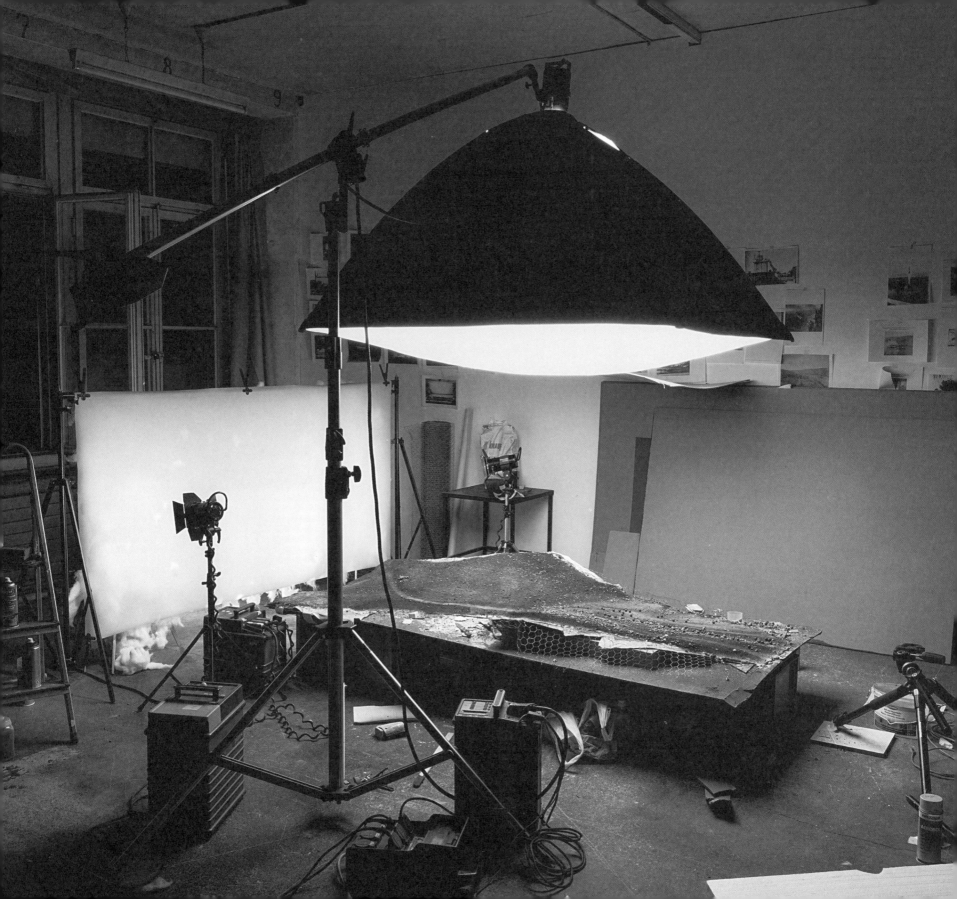

GLORIOUS MAQUETTES
BY FLORIAN EBNER

The significance that some images have in our collective memory is shown in the afterlife that they lead. Major historical images that are specific landmarks in the history of photography not only live on in endless reproductions and publications, but also persist secondarily in the form of parody or homage.

Thus 'Raising the Flag on Iwo Jima', an award-winning picture taken by Joe Rosenthal on 23 February 1945, has a unique place as an emblem of America's victory in the Pacific War: reproduced millions of times over, the motif has been used for a postage stamp and a major war memorial; it has also featured in many books and films, and has been the subject of conjecture about the authenticity of the moment. Yet gradually this image has begun to take on a life of its own. There have been numerous paraphrases and parodies of the celebrated group of figures that have served both commercial and political purposes. A key example is the scene, captured on camera, of New York firefighters hoisting the Stars and Stripes on the smoking rubble of the World Trade Center: the photographer's recording of the moment evokes Rosenthal's precursor, a connection that has been analysed in detail by photography curator Clément Chéroux.

Images like 'Raising the Flag on Iwo Jima' are often called photographic icons. They derive their authenticity from the photographer's eyewitness account, and their potency stems from the reduction of complex historical circumstances to an event rendered as a picture. In some cases, only a single image has persisted through the endless process of reproduction to become firmly inscribed in our collective memory as a representation of wars and catastrophes, the charisma of a film star, or the quality of an artist.

The power of icons has consistently fascinated and perplexed artists. It has also challenged them to offer a different narrative rendering of these famous photographs. For example, there are numerous approaches based on the idea of re-enactment, of restaging the event for the camera with the help of actors. Other artistic methods use Photoshop to intervene in the image, editing in a detail or even deleting significant elements in the picture. What these strategies have in common is that they play with the mental image of the icons in the mind of the viewer.

Jojakim Cortis and Adrian Sonderegger take a different approach. Rather than focusing on the action and the moment, they emphasize the space and the construction of the image. They restore the depth of the three-dimensional space to the two-dimensional surface of the photographic icons, returning the instant in the past that has become enshrined in history to the constructed, present-moment reality of their studio. These compositions do not set out to conceal their constructedness but provocatively turn it outward. Moreover, the studio continues the world captured in the photograph beyond the boundaries of the image: the spotlight in Cortis and Sonderegger's studio becomes the spotlight in New York's Palladium in 1979, when Paul Simonon smashed his guitar to pieces.

All of a sudden the original edges of the icons emerge as the crops and trims that have hitherto prevented us from seeing that all these great images might in reality have been artifices, moments constructed for the camera. The footprint of the first man on the moon was nothing more than an imprint in a sandbox in a photo studio. But isn't that what we've always thought?

Cortis and Sonderegger's re-enactments thus draw on the compositional power of these images, perpetuating or amplifying it, as when, for example, the outstretched arms of the American Olympic athletes giving the Black Panther salute are allowed to bleed into the dark studio backdrop, which seems to extend upwards to infinity.

At first sight, the two photographers' 'Making of...' might seem somewhat audacious when compared with the great historical models, yet the pair take it upon themselves to recreate the settings from nearly two centuries of photographic history, conjuring them time and again out of nothing. They

achieve this with an almost boyish delight, revelling in the bricolage that is a characteristic feature of certain modernist works (one is reminded, for example, of another famous Swiss artist duo, Fischli/Weiss).

Nonetheless, the seemingly irreverent chaos surrounding Cortis and Sonderegger's studio compositions is also a precise and profound comment. Their interpretation of 'Raising the Flag on Iwo Jima' encounters its heroic forebear with the necessary ironic distance. Thus the plateau at the top of the mountain is raised up from the studio floor by standing it on two ordinary plastic crates. In compositional terms, the glue gun inversely mirrors the diagonal of the flagpole, which the grey-clad group of figures, matching the original black-and-white, is about to raise aloft. It is no coincidence that another American flag lies on the studio floor: the now-famous picture actually captured the hoisting of a second, larger flag.

This series by Jojakim Cortis and Adrian Sonderegger sends a major blast of fresh air through the eternal circulation of icons. Rather than appropriating the photographs for political purposes, they inject them with their brand of visual humour, as they invite us to take a close look at the composition of their images. It is a playful reminder that the great icons of history do not simply appear out of nowhere but are also informed by a constructive will: 'You don't take a photograph, you make it!' (Alfredo Jaar, appropriating a sentence attributed to Ansel Adams). This form of homage is not the worst thing that can happen to these illustrious images.

EVERY IMAGE IS A CONSTRUCTION
BY CHRISTIAN CAUJOLLE

There are some words which, because they have been used too frequently and inappropriately, have lost much of their original sense. Worse still, they find themselves in the position of being misunderstood, or seen as pretentious, frivolous or ultimately meaningless.

'Icon' has unfortunately become one of those words. By referring to any sort of product or experience – whether visual or not – as 'iconic' and calling any model who's about to spend a few months as a minor star in the fashion and media firmament as a 'new icon', the media have played a considerable role in trivializing the term. Worse yet, they have begun to use it in place of other, more suitable words and have forgotten where the term originally came from. In ancient Greek, eikon meant 'image', but the word quickly came to be applied primarily to religious imagery that served a particular function, with all the ambiguity and questions regarding the legitimacy of representing gods that this implies. In the Orthodox Christian tradition, icons soon became valuable, sophisticated and costly objects, often acquiring an almost relic-like status.

In a world constantly awash with streaming images, in a visual culture that increasingly tends to see false equivalences in representations of nature that are actually very different, the very concept of an icon becomes problematic. Is our society, in which the photographic image is no longer merely a stored memory, still able to produce icons? In order to find out, and given that the process through which a photograph becomes an icon has not yet been truly decoded or understood, it becomes increasingly necessary to try to define what icons are, or at the very least, what they were. This is the task attempted by Jojakim Cortis and Adrian Sonderegger, who have given their ingenious, appealing but nonetheless very serious photographic series the title of 'Icons' (also known as 'Making of…'). In so doing, they are engaging in a practical analysis of the history of photography and questioning the very nature of their chosen medium of expression.

It has long been known that one of the key aspects of modernity is the ability to question the nature, limits and functions of artistic practice. It is also well known that the role of the viewer or audience in creating the meaning of artworks can no longer be ignored. All of these elements are present in the development of Cortis and Sonderegger's series. Taking the idea to its logical conclusion, they use photography to dissect the process of photography and reveal its inner workings. As truly contemporary artists, they grasp both the medium and its history, shaking it up and stripping it bare, and they have enough taste to do it with a touch of wit that avoids the potential risk of preachiness.

The approach is straightforward: it consists of making it plain that any photograph – any image, in fact – is a fabrication, a makeshift job. The playfulness with which these two partners-in-crime set out their organized chaos of tools, paper, sticky tape, craft knives and pots of paint or ink seems celebratory. It's like a gleeful trick planned and staged by mischievous boys, as they cast a mocking eye over a near two-hundred-year history of images, from Joseph Nicéphore Niépce's first-ever photograph to William Eggleston's red ceiling and a landscape by Andreas Gursky that was fought over at auction by collectors. We could view the series of chosen images as a suggested reading of the established history of photography, or as a questioning of its conventions. In the way that the pair carefully control their model 'reconstructions', we can see them taking up a stance and yet at the same time dismantling a system of values. More precisely, they encourage us to re-examine the nature of icons, or rather the different methods by which they are (or were) created.

This brilliant and often witty series is a salutary reminder of the fact that every image is the result of a process and it would be both inaccurate and dangerous to confuse it with reality. The studio set-up, the model-making, the clever use of scale, the presence of professional technical equipment – such as light stands, which usually have no place in the world of photo-journalism – allow us to decipher the process and, at the same time, make

us doubt what we see. More exactly, we can no longer tell whether the image we are looking at is real or fake news. It is an image that has been physically constructed and lit, and although it is not a simple reproduction of the original photograph, it possesses the qualities that made the original image into a collective symbol, most notably the physical position of the camera. All of this is done with both an obsessive attention to detail and a sly wink. Without being explicit about it, the two artists half admitted as much regarding the first image they recreated, 'Rhein II' by Andreas Gursky, dating from 1999. This large-format landscape (190 × 360 cm [74⅞ × 141¾ in.] in a 210 × 380 cm [82⅝ × 149⅝ in.] frame), one of the German photographer's most abstract works, shows the Rhine running horizontally across the image space, with green fields on both of its banks under a cloudy sky; it sold at auction in 2011 for $4.3 million, making it the world's most expensive photograph at the time. Cortis and Sonderegger explain: 'We studied photography at Zurich University of the Arts and graduated in 2006. We started to work together and after graduating we looked for commercial work that would allow us to make a living. In 2012 we decided to do something much more personal, something that was really a passion for us. It was summer and we had no work coming in, so we got the idea of recreating the most expensive photograph in the world. After Gursky, we wanted to copy other expensive photographs, but we ran into a problem. Many of these photographs contain people and recreating a person in model form, out of clay, is extremely difficult, often too difficult to attempt without it looking ridiculous. For that reason, we decided to broaden our field and work with icons – at least, with the ones that we were able to recreate.' It is important to note that the basic idea is not to copy or reproduce; instead, the project fits within one of the major strands of contemporary photography, that of the mise en scène or staged scene, a style of photography that has existed in many other varied forms since the earliest days of the medium.

Here we find Niépce's first photograph, then more recently Henri Cartier-Bresson's man jumping puddles by the Gare St Lazare, and other icons of photographic history, like Robert Capa's falling soldier. We also see images like the Concorde crash, oil spills, or the Kennedy assassination, which have been impressed on our memories not because of their aesthetic qualities but because they are linked to events of global importance. There are therefore two kinds of icon, which combine, connect and eventually form the 'brief history of photography' as interpreted by these two young artists. It is a history full of chance events, but it includes both types of icon, if we are willing to accept this as an umbrella term for the images that constituted our shared visual culture of the twentieth century, before the digital revolution made image-making commonplace. It is quite rare – with the exception of Capa's Spanish militiaman, whose authenticity is so often doubted – to find photographic excellence coinciding with a major news story. But it remains undeniable that the first century of photography was marked not only by formal innovations that reflected the evolution of the human gaze but also by the visual recording of events. And although these were presented in the press as vessels of objectivity and truth, they were in fact fabrications, and their acceptance into our collective heritage was based either on the seriousness or tragic nature of the events that they accompanied, or because their visual style made them particularly memorable.

This timely project, which is very much in keeping with the contemporary trend towards the re-reading of photography and its history, demonstrates to us that every image is a construction – first mental, then physical. Photographers working in the field often say that they seek, and sometimes find, images in the real world that already exist in their heads. Jojakim Cortis and Adrian Sonderegger feed off a history of photography that remains – at least for now – a kind of collective memory, bringing together forms, events, essays, points of view. They have cleverly found just the right tone to encourage us to think about the nature of this illusory memory, yet without being either destructive or didactic. And they are right. Surely our primary experience of the modern world is no longer physical but mediated through images, and therefore it continues to be influenced by the alluring illusion of icons.

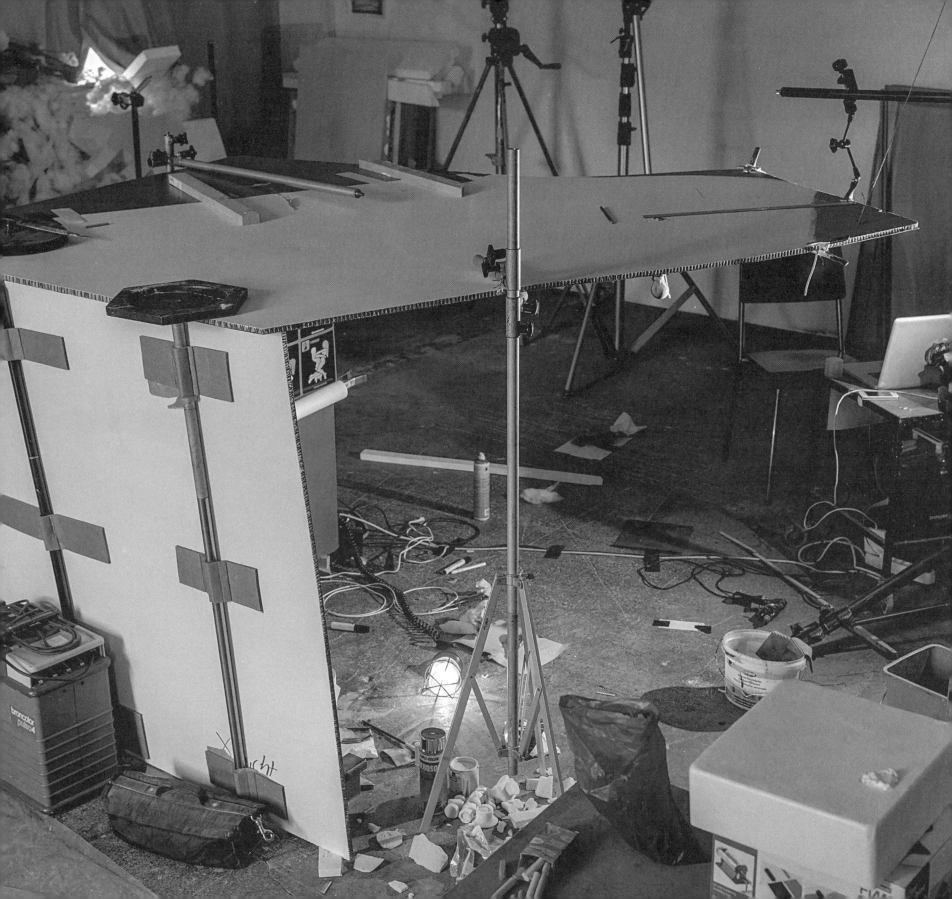

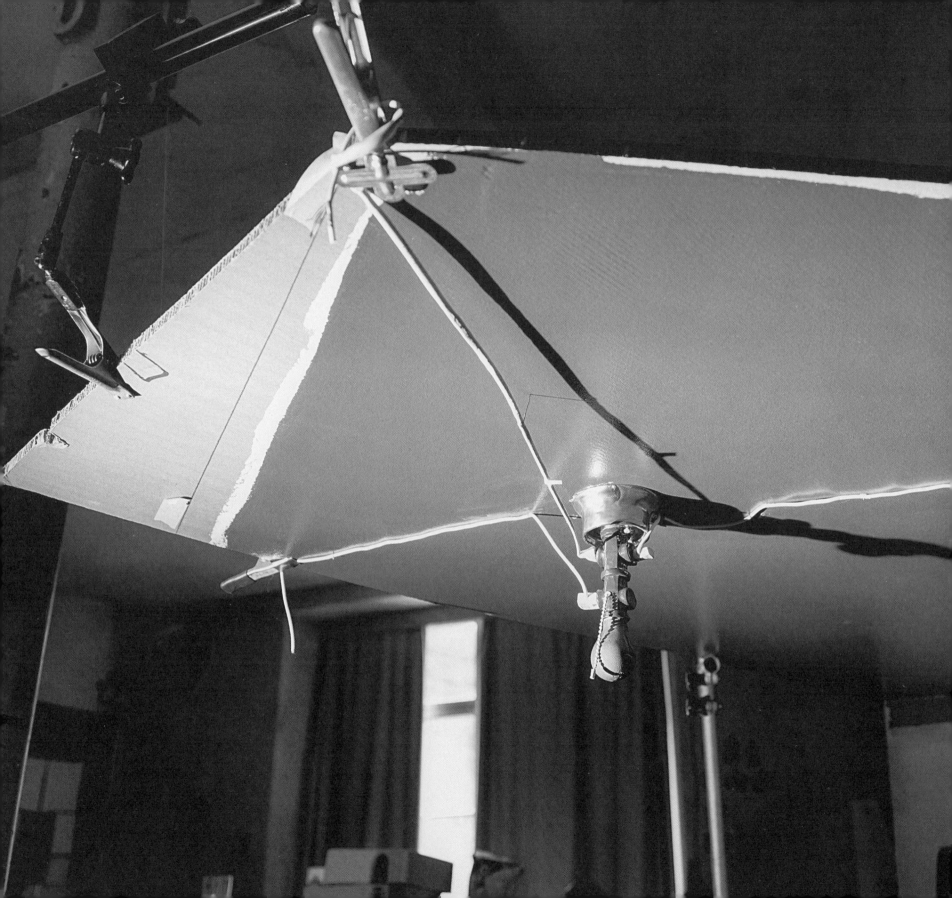

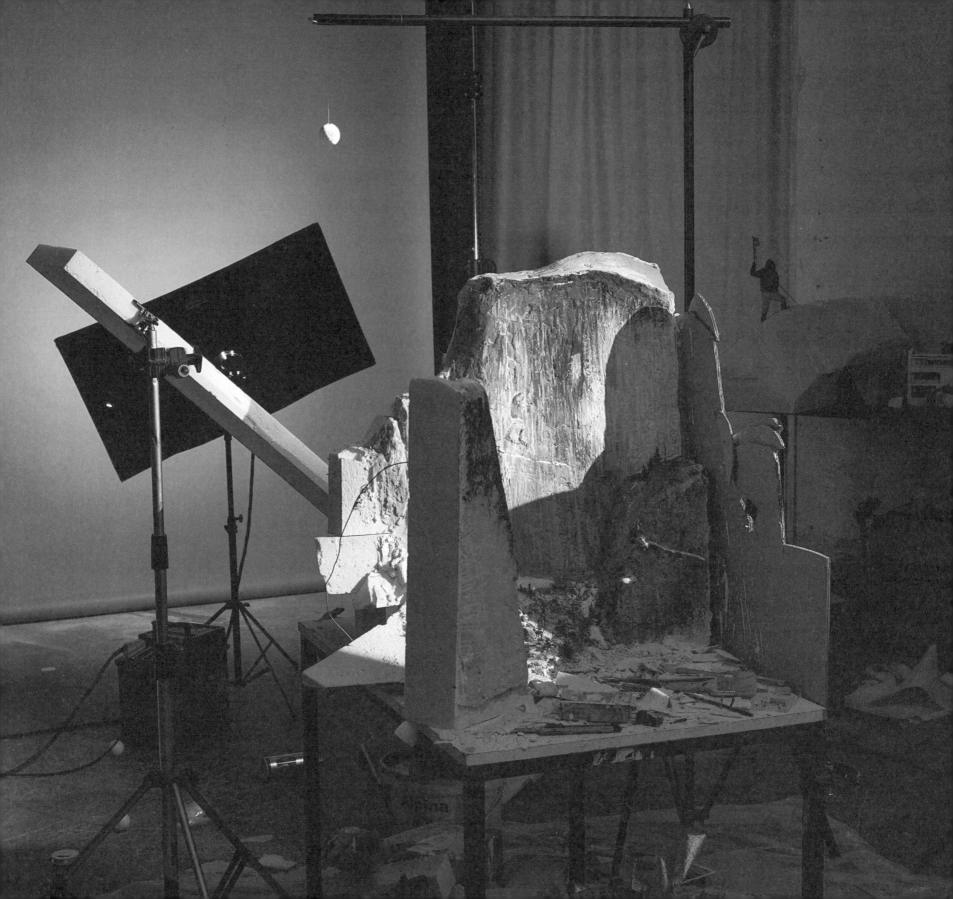

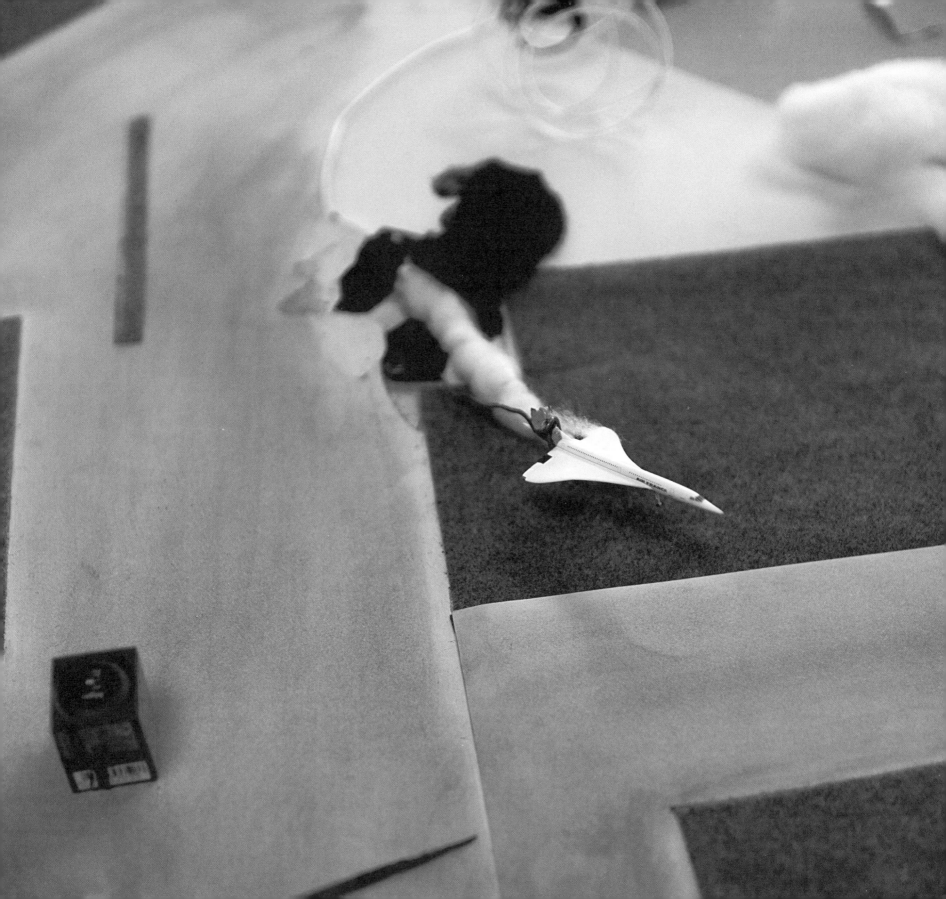

PLATES

'View from the Window at Le Gras' is the earliest surviving photograph in existence. It was created around 1826 by French inventor Joseph Nicéphore Niépce (1765–1833), and it depicts part of his country estate, Le Gras, as seen from a high window. Niépce used a camera obscura to make the image, and – after much trial and error – employed bitumen of Judea spread over a pewter plate. During an exposure time of some eight hours, light hardened the bitumen where it hit; the unhardened bitumen was then washed away with lavender oil, revealing a rudimentary image of rooftops and countryside. Niépce was secretive about the processes he used for his 'heliography' ('light writing'), and his work was not recognized by the Royal Society in London, which he visited in 1827. However, he was championed by botanical illustrator Francis Bauer, to whom he donated the photograph and other specimens. The photograph disappeared after 1905, but was tracked down in 1952 by photo historian Helmut Gernsheim. It is now housed at the Harry Ransom Center in Austin, Texas.

Making of 'View from the Window at Le Gras'
(by Joseph Nicéphore Niépce, *c.* 1826), 2013

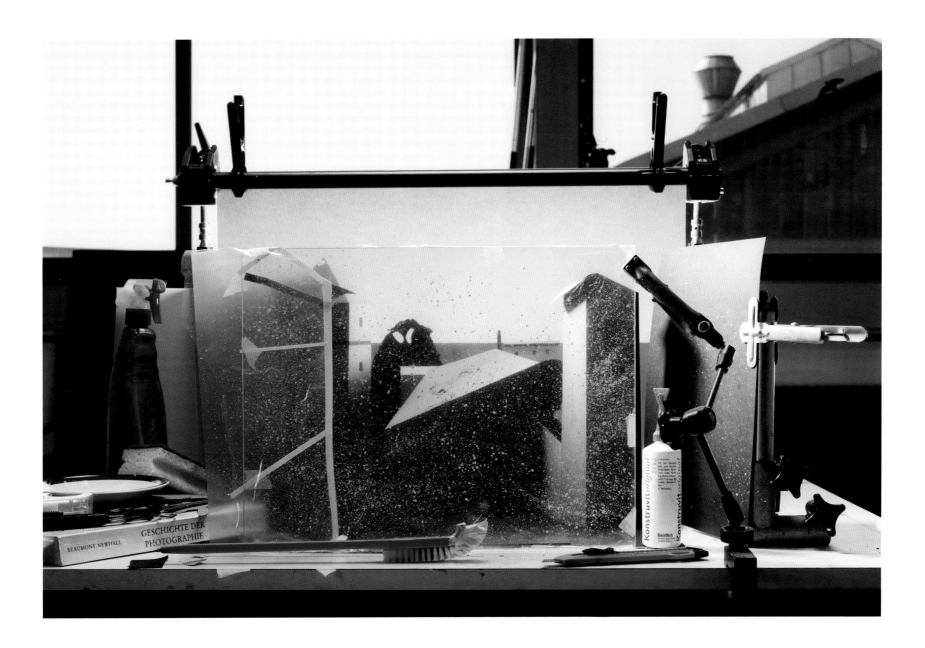

A now famous image, showing a barren landscape littered with cannonballs that at first appear like rocks, was one of more than three hundred that constituted the first extensive photo-documentation of war. In 1855, British photographer Roger Fenton (1819–1869) arrived at the Crimean Peninsula, on assignment from the fine arts dealer Agnew & Sons, to photograph the war that was being waged against Russia by England, France, Turkey and Sardinia. He sent back photographs taken on large box cameras with glass-plate negatives that were developed using the difficult and unstable wet-collodion process, additionally hampered by flies and dust. His images included shots of the 'Valley of Death', its name borrowed from the 23rd Psalm by British soldiers who faced constant shelling there. Fenton reported in a letter to his wife: 'in coming to a ravine called the valley of death, the sight passed all imagination [:] round shot & shell lay in a stream at the bottom of the hollow all the way down [;] you could not walk without treading upon them....' Fenton's haunting image eschewed portrayal of actual conflict or of the dead and wounded, but captured a profound sense of desolation. Another photograph with fewer cannonballs visible on the right-hand side also exists, which may indicate stage-setting by Fenton.

Making of 'Valley of the Shadow of Death'
(by Roger Fenton, 1855), 2015

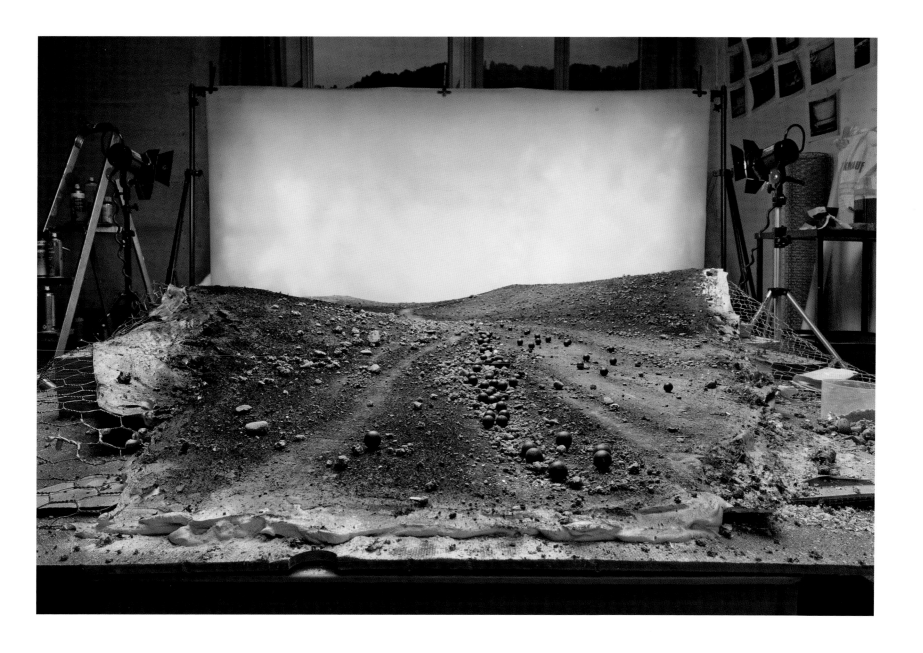

Louis-Auguste Bisson (1814–1876) opened a photographic studio in Paris in 1841, and soon afterwards his brother Auguste-Rosalie (1826–1900) joined him. The pair soon became well known as the 'Bisson frères', making celebrated images of Napoleon as well as of landscapes and architecture in Spain, Italy, Belgium, the Netherlands and Germany. In 1861, Auguste-Rosalie became the first person to take photographs from the summit of Mont Blanc, the highest peak in the Alps. He had attempted the ascent in 1859 and again in 1860; now he returned, with a guide and a retinue of twenty-five porters to carry his cameras, photographic plates, chemicals and darkroom tent. He made his images using the wet-collodion process, and favoured unusually large-format negatives. His team battled the altitude, extreme cold, snowstorms and avalanches to reach the summit of the mountain on 25 July 1861. Bisson exposed three negatives. During the descent, he set up his equipment once again and posed members of the crew as if documenting their ascent. The Bisson brothers' images of local scenery and buildings proved very popular with both the general public and scientists, who were eager for accurate depictions of previously little-documented territories.

Making of 'Mont Blanc, La Jonction' (by Louis-Auguste Bisson and Auguste-Rosalie Bisson, 1861), 2014

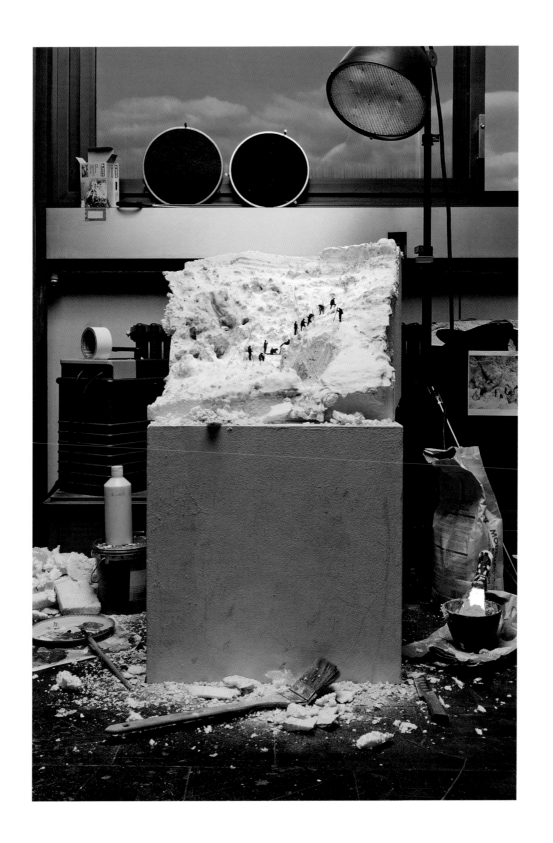

In October 1863, Ferdinand Maximilian Joseph – second son of Archduke Franz Karl, Emperor of Austria – took the fateful decision to accept Napoleon III's offer to become Emperor Maximilian I of Mexico. His regime was unstable from the start. Loyalists and republicans soon clashed, and on 15 May 1867 the emperor was captured. Following a court-martial, he was sentenced to death. The French photographer, François Aubert (1829–1906), who had settled in Mexico in 1860 and become a regular photographer of the emperor and his court, did not have authorization to photograph the execution. However, he photographed the emperor's shirt, stained with blood and riddled with bullet holes from the firing squad. He also photographed the emperor's embalmed corpse upright in its coffin, and the site of the execution marked with wooden crosses. Copies of these photographs – sold as *cartes-de-visite* – were purchased in great numbers by the emperor's opponents and followers alike. It is said that Édouard Manet relied on Aubert's images for his series of historical paintings on the subject, and Aubert has been credited with playing a part in ushering in the new genre of photojournalism.

Making of 'The Shirt of the Emperor, Worn During his Execution'
(by François Aubert, 1867), 2017

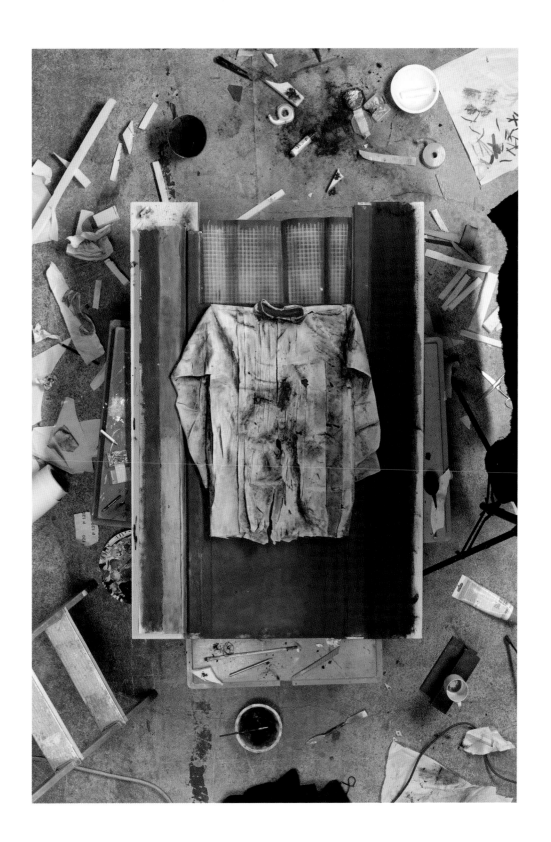

On 17 December 1903, in Kill Devil Hills, North Carolina, John Thomas Daniels (1873–1948) captured an image of the first flight of a powered aeroplane, as achieved by Orville and Wilbur Wright (in the photograph, Orville is piloting the plane, with his brother running alongside). It was the first photograph Daniels had ever taken; he had never even seen a camera before. The Gundlach Korona 5 × 7-inch glass-plate view camera was owned by the Wright brothers, who were keen to memorialize the occasion and to have a record in case of future patent claims. Daniels, a member of the local Life-Saving Station, was so enthralled by the moment of flight that he almost forgot to squeeze the shutter-release bulb, as Orville – having set up the tripod and focused the camera – had instructed him to do. On its fourth flight that day, the plane was caught by a powerful gust of wind and crashed. Several weeks later, back in their native Ohio, the brothers developed the iconic plate. Daniels died on 31 January 1948, one day after Orville Wright.

Making of 'The First Powered Flight of the Wright Brothers' Flyer 1' (by John Thomas Daniels, 1903), 2013

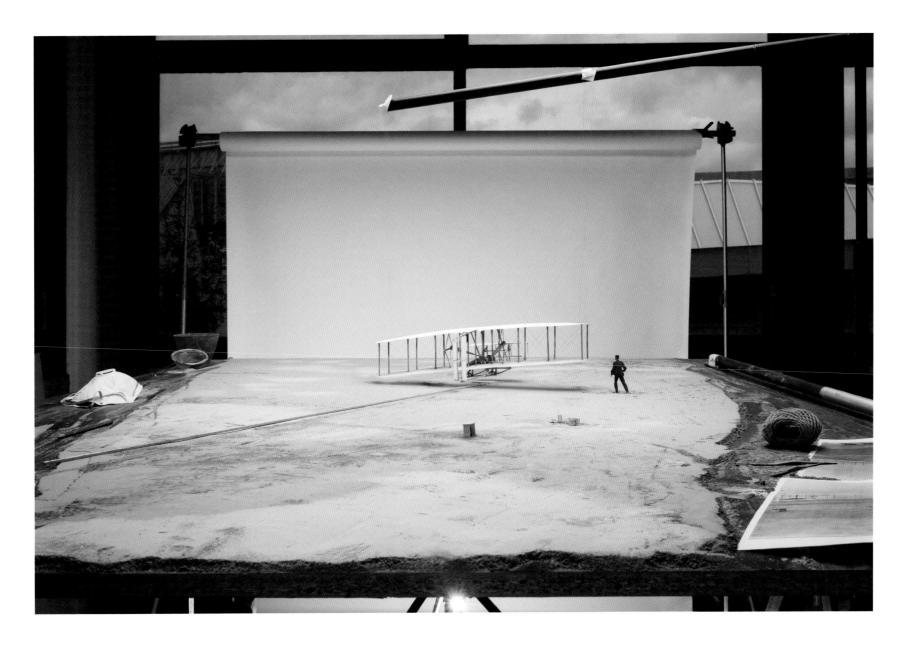

The Luxembourg-born, Milwaukee-raised Edward J. Steichen (1879–1973) made his name as a photographer in the Pictorialist movement, which was defined by manipulation rather than straightforward recording of a subject. The image was thus 'created', thereby differentiating high art from the simple snapshot. For the 'Flatiron', made in 1904, Steichen suspended pigment in gum bichromate and applied this over a platinum print to emulate 'painterly' effects. He made three versions, one of which was selected by the influential leader of the Pictorialist circle, Alfred Stieglitz, for inclusion in the 'International Exhibition of Pictorial Photography' held at the Albright Art Gallery in Buffalo, New York, in 1910. The photograph portrays the landmark Flatiron Building designed by architect Daniel Burnham for a triangular site at the intersection of Fifth Avenue and Broadway in New York. Steichen's tonality deliberately echoes Whistler's *Nocturne* paintings, and the inclusion of the tree branch recalls the Japanese *ukiyo-e* prints that were in vogue at the time. The building and street scene, however, convey American dynamism and modernity, with the glow of electric light and the soaring skyscraper cut off at the top of the frame. Steichen's atmospheric image is representative of a particular period, but it has also achieved an aura of timelessness.

Making of 'Flatiron – Evening' (by Edward J. Steichen, 1904), 2016

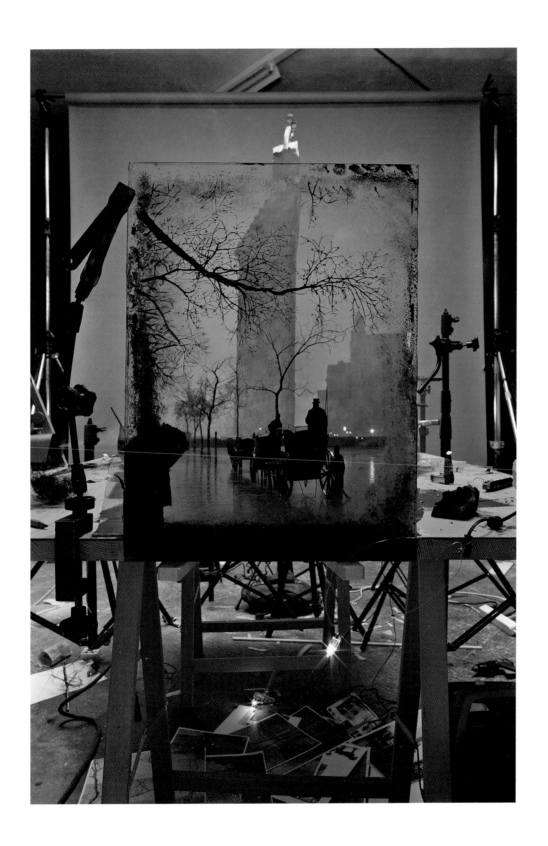

RMS *Titanic* – the supposedly 'unsinkable' British passenger liner – collided with an iceberg on her maiden voyage from Southampton to New York and sank in the North Atlantic Ocean on 15 April 1912. More than 1,500 passengers and crew perished. All trace of life on board would have gone down with the ship but for an act of providence that saved the Irish Jesuit priest Francis Browne (1880–1960). Having been given a ticket by his uncle Robert, Bishop of Cloyne, Browne sailed on the ship's first leg from Southampton to Queenstown in Ireland. He would have continued, having been offered an onward ticket by a wealthy American couple he befriended in the dining saloon. However, on sending a telegraph requesting permission from his superior, he received an unequivocal order to disembark. He took with him his camera, which contained the only surviving photographs of the *Titanic* at sea, including the last known picture of the captain, Edward J. Smith. Images appeared in publications all around the world. Browne's photographs were lost after his death but rediscovered by another priest, Edward O'Donnell, 25 years later. Browne's lifetime hoard – stored in a trunk, mainly on combustible nitrate-based film – consisted of an astonishing 42,000 negatives.

Making of 'The Last Photo of the Titanic Afloat'
(by Francis Browne, 1912), 2014

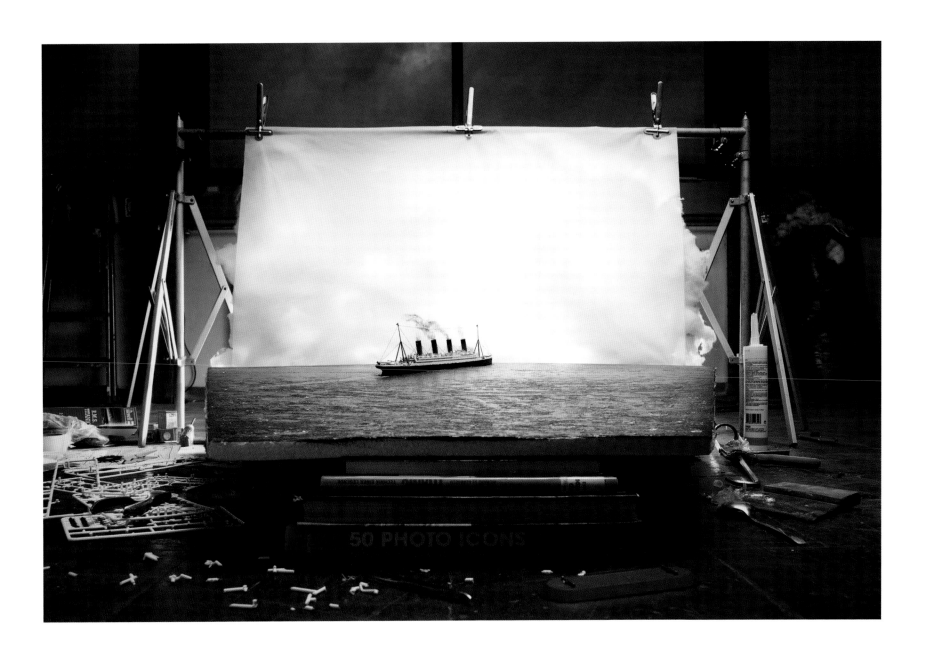

Jacques-Henri Lartigue (1894–1986) was seven years old when his father gave him his first camera. His early images, which he preserved in multiple albums, have become associated with the Belle Époque, the period of prosperity and optimism preceding the First World War. Lartigue photographed the environment of his privileged background, often capturing fleeting motion: subjects in the act of jumping, gliders and kites in mid-air, elegant women perambulating. He also photographed the Grand Prix of the Automobile Club de France, which took place in Amiens on 12 July 1913. The No. 6 car – a Théophile Schneider driven by René Croquet – was one of the favourites, though it did not actually win. It has been suggested that Lartigue took his picture on a glass-plate negative using a large-format ICA Reflex camera with an f/4.5 lens, which would have been fast for the time. The distortions are striking, probably caused by the panning of the camera and the action of the shutter. Lartigue later devoted himself to painting, and his photography was not discovered until the 1960s. 'Grand Prix A.C.F.', with its impression of exhilarating speed, speaks of the exuberance of a carefree age.

Making of 'Grand Prix A.C.F.' (by Jacques-Henri Lartigue, 1913), 2016

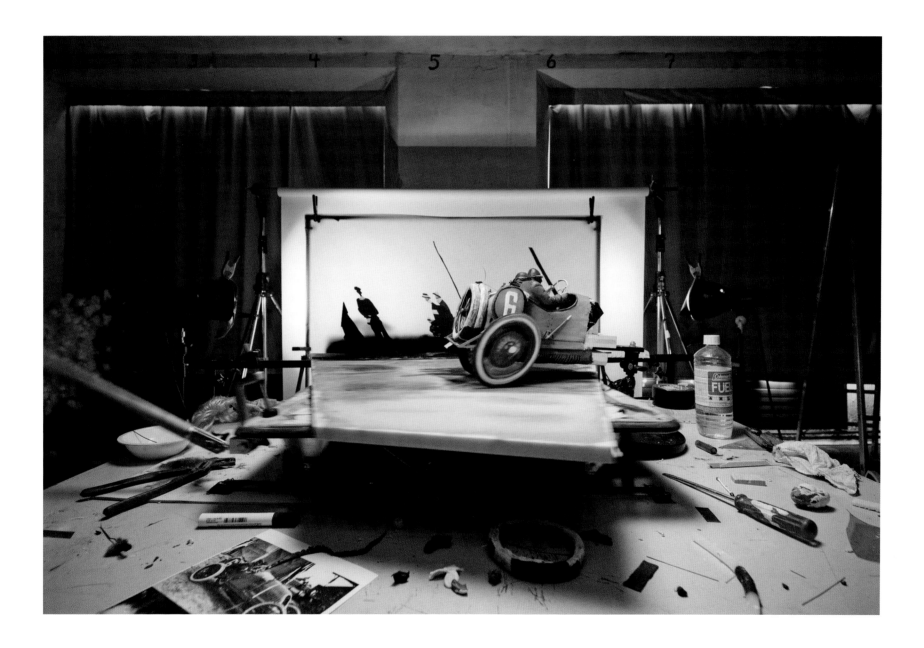

The most famous photograph by Ernest Brooks (1876–1957) shows five soldiers from the 8th East Yorkshire Regiment moving towards the frontline during the First World War. Complete with helmets, rifles and backpacks, they are seen silhouetted against a dramatic sky, with rays of sunlight emerging from lowering clouds. On 4 October 1917, the day the photograph was taken, the battle of Broodseinde was fought near Ypres in Flanders; it turned out to be the most successful Allied attack of the Passchendaele campaign. Brooks was the first official photographer to be appointed by the British military. At first he had no qualms about posing photographs or recreating scenes he had witnessed previously. However, after fellow journalists exposed him, he abandoned this practice. Two of his silhouette photographs were published in *The Sphere* newspaper on 20 October 1917 and proved very popular with the public, perhaps because of the anonymous 'everyman' nature of their subjects, or because they successfully captured small moments of humanity amid the conflict and carnage.

Making of 'Five Soldiers Silhouetted at the Battle of Broodseinde'
(by Ernest Brooks, 1917), 2013

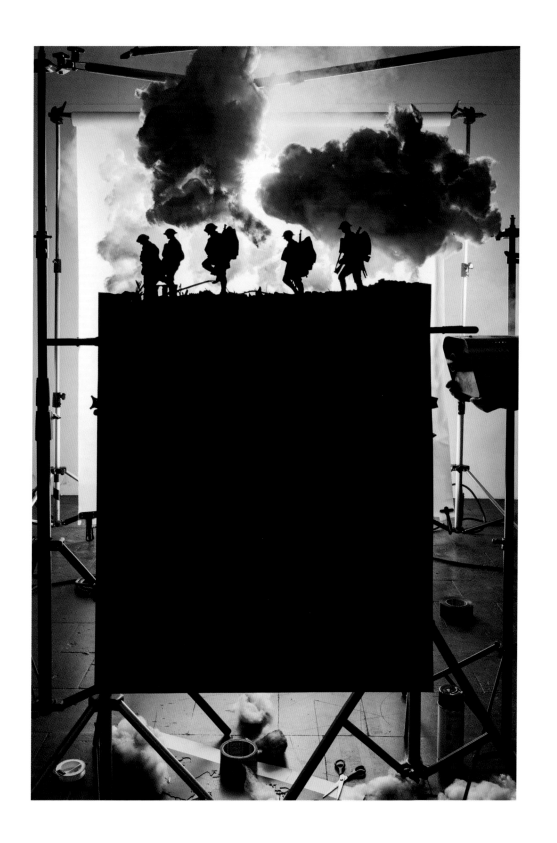

In 1933, a new road was completed along the northern shore of Loch Ness in Scotland. Shortly afterwards, a couple claimed to have spotted an 'enormous animal' in the water. *The Inverness Courier* reported the story, describing what the couple saw as a 'monster'. Thus began the legend of 'Nessie', attracting tourists and conspiracy theorists alike. The *Daily Mail* invited the big-game hunter Marmaduke Wetherell to track down the monster. When the hunter returned with photographs of giant footprints, the newspaper investigated and determined that the prints had been made with a dried hippopotamus foot (it was common to make umbrella stands from hippo feet at the time), leaving Wetherell humiliated. Then in April 1934, a British physician, Dr Robert Wilson (1899–1969), came forward with an image purporting to show a sea serpent in the loch. He declined to have his name associated with the picture, which came to be known as the 'Surgeon's Photograph'. Some considered this to be concrete evidence of Nessie's existence. However, in 1994 Wetherell's stepson, Christian Spurling, confessed that his discredited and ridiculed stepfather had asked him to create a model of a sea monster, which he did using a toy submarine and a wooden head and neck. The model was placed in the loch and carefully photographed. Analysis of the image has confirmed a number of discrepancies indicating that the picture is a hoax.

Making of 'Nessie' (by Marmaduke Wetherell, 1934), 2013

The photograph of the death of a loyalist militiaman, sometimes known as 'The Falling Soldier', taken by Robert Capa (1913–1954), has been called one of the greatest war photographs ever made. It captures the very moment of death near Espejo in Córdoba, Spain, in early September 1936, of a Republican militiaman. Or does it? Since the mid-1970s, doubts have been raised over the photograph's authenticity. Staged photographs were relatively common during the first year of the Spanish Civil War, as photojournalists were granted only limited access to fields of combat. Capa himself gave contradictory accounts of the taking of the photograph – his vantage point, his technique, whether the deadly weapon was a machine gun or a sniper's rifle. The negative is thought to have been lost in the 1930s.

Making of 'Death of a Loyalist Militiaman, Córdoba front, Spain, early September 1936' (by Robert Capa, 1936), 2016

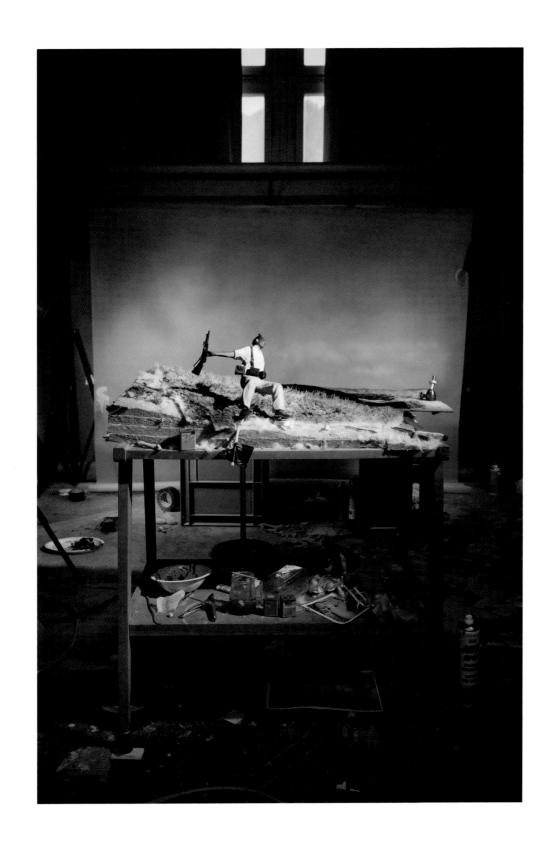

In the summer of 1936, *Fortune* magazine sent photographer Walker Evans (1903–1975) and staff writer James Agee (1909–1955) to the American South to document the plight of impoverished tenant farmers living through the Great Depression. The two New Yorkers spent several weeks in the devastated cotton belt of Alabama, where they focused on three families, including the Burroughs. Evans, who had just finished some assignments as a Farm Security Administration photographer, aimed to produce dispassionate, objective, non-propagandist images. His gelatin silver prints included shots of sharecropper Floyd Burroughs's sparsely furnished cabin (it has been suggested that Evans may have moved, rearranged or removed objects), as well as portraits of the family's everyday life. The extensive finished article was never published, but it eventually became a book, *Let Us Now Praise Famous Men*. Though this sold poorly on its initial printing, interest was renewed in the 1960s and it is now regarded as one of the twentieth century's great literary masterpieces.

Making of 'Part of the Bedroom of Floyd Burroughs' Cabin' (by Walker Evans, 1936), 2015

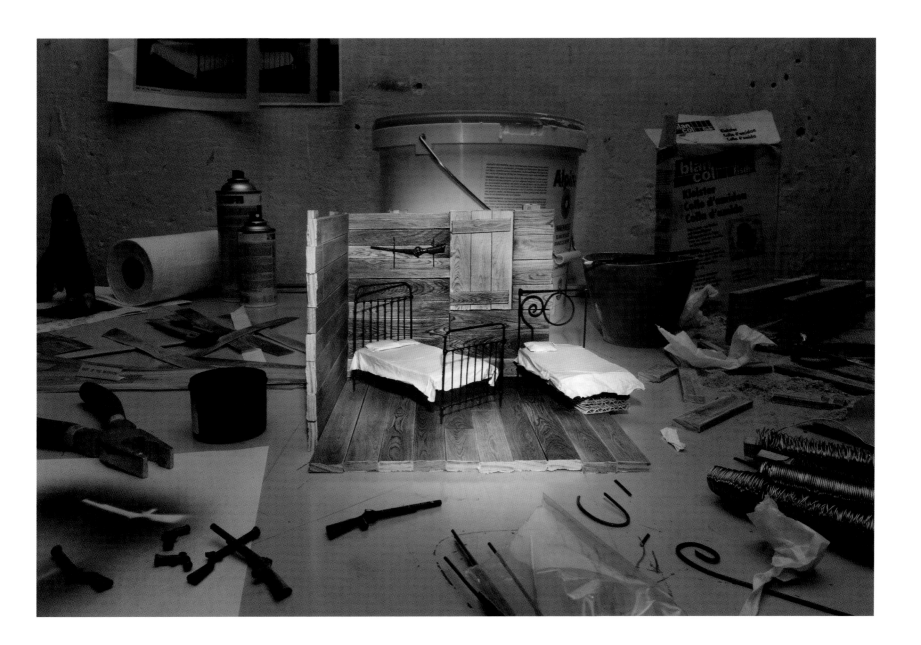

The 1930s brought the age of the Zeppelin – the luxurious, majestic skyliner capable of transatlantic flight. However, on 6 May 1937, the LZ 129 *Hindenburg* caught fire as it attempted to dock at the Lakehurst Naval Air Station in New Jersey. Thirty-six people were killed (13 passengers, 22 crewmen and one worker on the ground). The disaster was widely covered in newsreels, photographs and Herbert Morrison's anguished eyewitness broadcast for radio; motion-picture footage was even played in movie theatres across the globe. The event heralded the end of the airship era. Photojournalist Sam Shere (1905–1982) was present to capture the scene. 'I had two shots in my big Speed Graphic,' he later recalled, 'but I didn't even have time to get it up to my eye. I literally "shot" from the hip – it was over so fast there was nothing else to do.' His spectacular, tragic photograph won him the Editor and Publisher Award for best news picture of 1937.

Making of 'The Hindenburg Disaster' (by Sam Shere, 1937), 2014

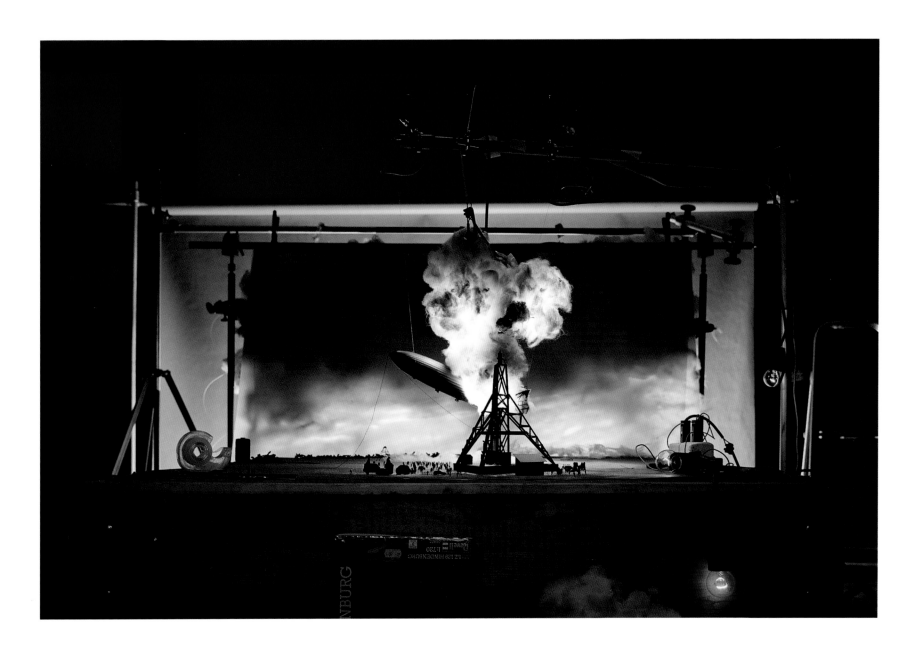

Following Japan's invasion of Manchuria in 1931, relations between China and Japan deteriorated to the point that war broke out in 1937. US military intervention became increasingly likely. On the morning of 7 December 1941, with the aim of preventing the US fleet from interfering with military operations in the Pacific, the Japanese launched a surprise pre-emptive attack on the American naval base at Pearl Harbor, Hawaii. Over 350 fighter planes conducted a relentless bombing raid, killing 2,403 American military personnel and civilians, injuring a further 1,178, sinking four US battleships and destroying 169 US aircraft. The following day, the US declared war on Japan. Among the boats that were attacked was the USS *Shaw*. The blast that exploded the ship's ammunition store was dramatically caught on camera by an unknown US Navy photographer. Remarkably, after repairs, the *Shaw* was able to return to battle, and went on to become one of the most highly decorated destroyers in the US Pacific fleet before finally being decommissioned on 2 October 1945.

Making of 'Attack on Pearl Harbor'
(by unknown US Navy soldier, 1941), 2015

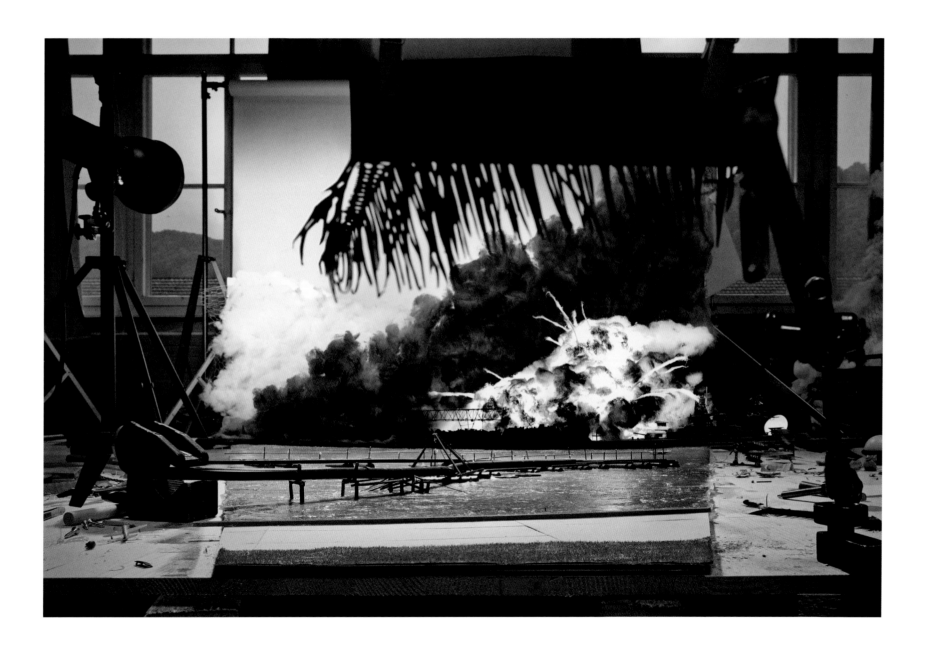

On 1 January 1945, Polish photographer Stanisław Mucha (1895–1976) captured a view of the railway entrance to a concentration camp. Established in 1940, the original camp was located on the outskirts of the city of Oświęcim, which was annexed to the Third Reich and renamed Auschwitz; over its almost five years of existence, it was expanded by the Nazis to encompass a number of sub-camps, including Birkenau. Rudolf Höss was its longest-serving commandant. In an affidavit made at Nuremberg on 5 April 1946, he stated: 'I commanded Auschwitz until 1 December 1943, and estimate that at least 2,500,000 victims were executed and exterminated there by gassing and burning, and at least another half million succumbed to starvation and disease, making a total dead of about 3,000,000. This figure represents about 70 or 80 percent of all persons sent to Auschwitz as prisoners, the remainder having been selected and used for slave labour in the concentration camp industries; included among the executed and burned were approximately 20,000 Russian prisoners of war…. The remainder of the total number of victims included about 100,000 German Jews, and great numbers of citizens (mostly Jewish) from Holland, France, Belgium, Poland, Hungary, Czechoslovakia, Greece, or other countries. We executed about 400,000 Hungarian Jews alone at Auschwitz in the summer of 1944.' On 16 April 1947, Höss was hanged next to the crematorium of the main Auschwitz camp.

Making of 'KZ Auschwitz, Gateway' (by Stanisław Mucha, 1945), 2015

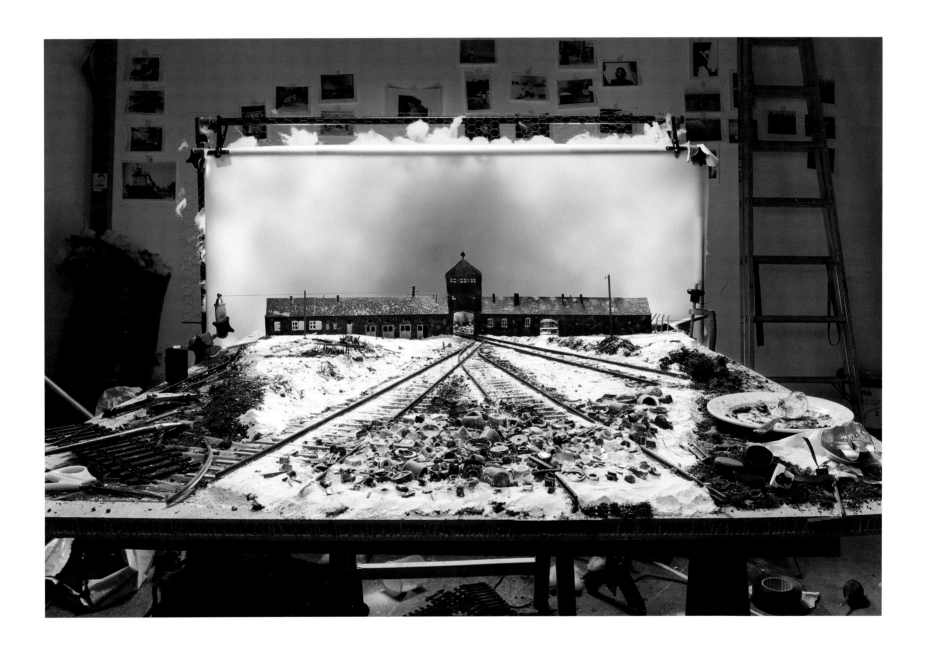

The photograph of 'Raising the Flag on Iwo Jima' was taken on 23 February 1945, during the battle to capture the Japanese island. The photographer was Joe Rosenthal (1911–2006) of the Associated Press. The image, published in US newspapers on 25 February, is considered to be one of the most widely reproduced photographs of all time, and is, to date, the only photograph to win the Pulitzer Prize for Photography in the same year as it was taken. Despite its fame and place at the heart of US history, the image in fact depicts the second flag-raising to take place that morning. The first, although it was photographed, occurred before Rosenthal had reached the location, at the summit of Mount Suribachi. Upon arrival, he saw one group of US Marines following orders to take the first flag down, while a second group of six prepared to raise a second, larger flag. Rosenthal had to think and act quickly: he took his legendary photograph without even looking through the viewfinder of his Speed Graphic camera. As a consequence of the two flag raisings, the image is not without controversy – some claim it is staged. Rosenthal, however, denied this throughout his lifetime. The photograph is an enduring icon of victory in battle. As Rosenthal himself said: 'I took the picture; the Marines took Iwo Jima.'

Making of 'Raising the Flag on Iwo Jima' (by Joe Rosenthal, 1945), 2015

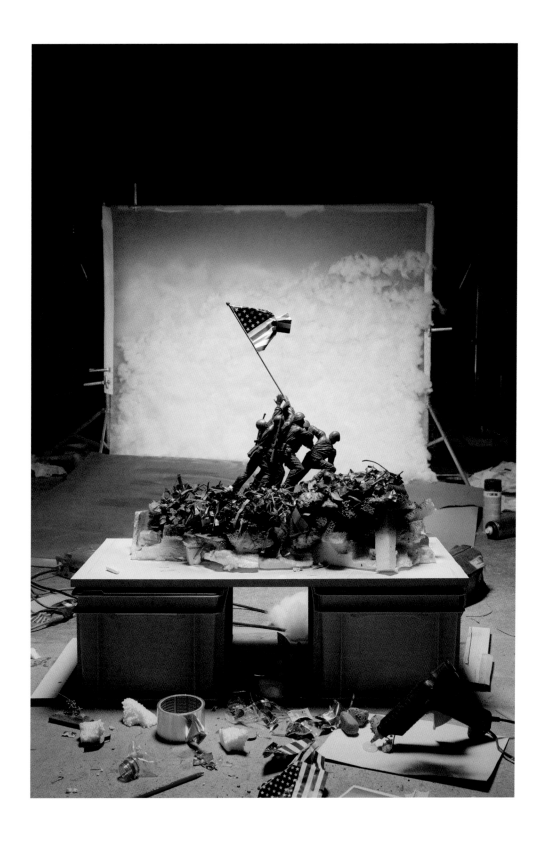

On 6 August 1945, the US Air Force B-29 bomber *Enola Gay* dropped an atomic bomb, codenamed 'Little Boy', on Hiroshima in Japan. Three days later, the Japanese were hit by an even more powerful bomb – nicknamed 'Fat Man' for its wide, round shape. The original target was Kokura, but heavy cloud cover obscured the city, so the mission proceeded to its secondary target, the sea port of Nagasaki. Here, some 40,000 citizens were killed outright; others died later from blast and burn injuries, and many more suffered long-term health effects including radiation sickness. Lieutenant Charles Levy (1918–1997) was on board *The Great Artiste*, one of the Superfortress bombers that was deployed in the attack. When later interviewed by the *Free Lance-Star* newspaper, he recalled: 'We saw this big plume climbing up, up into the sky. It was purple, red, white, all colors – something like boiling coffee. It looked alive … we were all plenty scared.' He took several photographs of the explosion, but the most powerful and widely circulated was of the vast mushroom cloud climbing into the stratosphere. Six days later, Emperor Hirohito announced Japan's unconditional surrender, bringing to a close the hostilities of the Second World War.

Making of '208-N-43888' (by Charles Levy, 1945), 2013

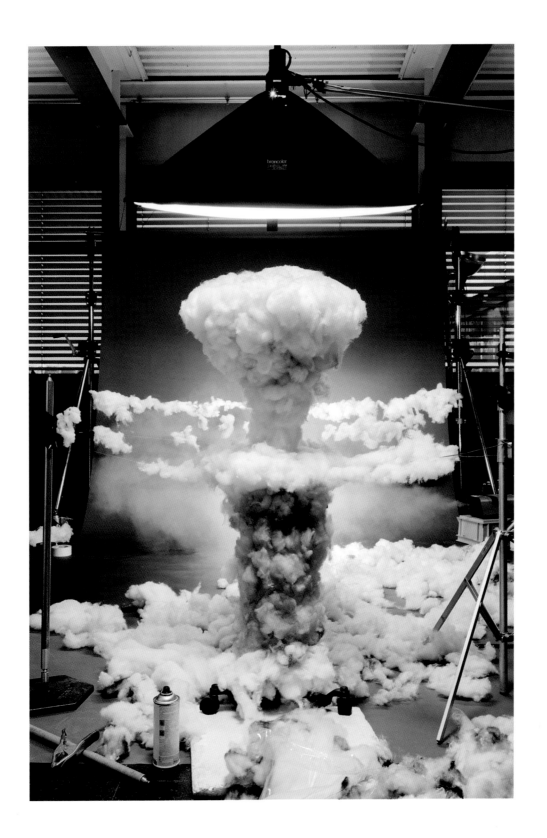

On 29 May 1953, the New Zealander Edmund Hillary (1919–2008) and the Nepalese Sherpa Tenzing Norgay (1914–1986) became the first men to reach the summit of the world's highest mountain, Mount Everest. The peak lies at 29,029 feet (8,848 m) above sea level. The ascent was achieved by the 1953 British Mount Everest expedition, led by Colonel John Hunt, and organized and financed by the Joint Himalayan Committee. This was the ninth attempt at the summit by a mountaineering expedition, and news of the success reached Britain just in time for the coronation day of the young Queen Elizabeth II. On reaching the summit, at 11.30 am, Hillary had shaken Tenzing by the hand ('in good Anglo-Saxon fashion', as he later reported), but the Sherpa then joyfully threw his arms around Hillary and pounded him on the back. They only stayed on the summit for 15 minutes, but Hillary took several photographs of the scenery – using his second-hand Kodak Retina, which he had modified so it could be used even through thick gloves – as well as a portrait of Tenzing standing triumphant on top of the world, holding aloft his ice axe on which were hung flags representing the United Nations, Great Britain, Nepal and India.

Making of 'Tenzing Norgay on the Summit of Mount Everest' (by Edmund Hillary, 1953), 2015

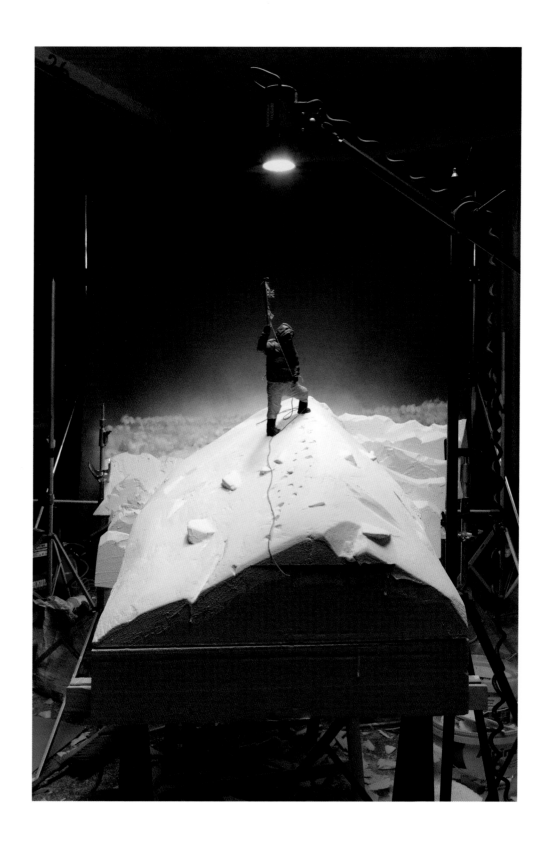

One of the most famous movie scenes of all time appeared in the romantic comedy *The Seven Year Itch*, directed by Billy Wilder. Filmed in 1954 and released in 1955, the movie starred screen idol Marilyn Monroe playing the part of an actress and former model. In the film sequence, Monroe and her co-star Tom Ewell exit the Trans-Lux Theater, then located at 586 Lexington Avenue in Manhattan, after watching the 1954 monster movie *Creature from the Black Lagoon*. A subway train passes underneath a grate in the sidewalk, and Monroe steps onto the grate, saying, 'Oh, do you feel the breeze from the subway? Isn't it delicious?' The wind then blows her dress up, exposing her legs. The scene was originally scheduled to be shot on location at the Trans-Lux Theater on 15 September 1954, but thousands of onlookers and photographers arrived. Wilder had to reshoot on a stage set at 20th Century Fox in Hollywood. The scene was photographed by Sam Shaw (1912–1999). Monroe's iconic white dress, created by costume designer William Travilla, sold at auction in 2011 for over $5.6 million. The notorious subway grate can still be seen at the corner of Lexington Avenue and 52nd Street.

Making of 'The Seven Year Itch' (by Sam Shaw, 1954), 2016

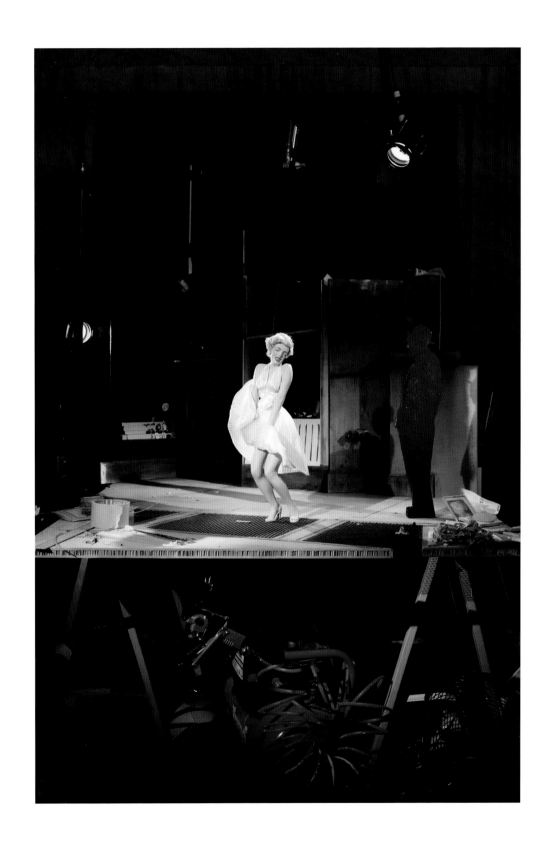

Russell A. Kirsch (b. 1929) was an engineer at the National Bureau of Standards (now the National Institute of Standards and Technology), working in Washington, DC. He led the team that developed the world's first digital image scanner. One of the first scanned images showed Kirsch's three-month-old son, Walden. The original photograph was captured as 30,976 pixels, in an area measuring approximately 2 × 2 in. (5 × 5 cm). By combining several black and white scans, which were made using different scanning thresholds, it was possible to add greyscale information. In the case of Walden Kirsch's image, two binary scans were combined to make a composite that showed approximate grey levels. After a long and illustrious career, Kirsch retired to Portland, Oregon, where the portrait of Walden now resides at the Portland Art Museum. The pioneering work of Kirsch's team was crucial to the development of digital photography, as well as playing a role in the invention of technology that would be vital to future space exploration; it was also key to medical breakthroughs such as CAT scans. In 2003, *Life* magazine named the scanned image of Walden one of the '100 Photographs that Changed the World'.

Making of 'Binary Scan' (by Russell A. Kirsch, 1957), 2016

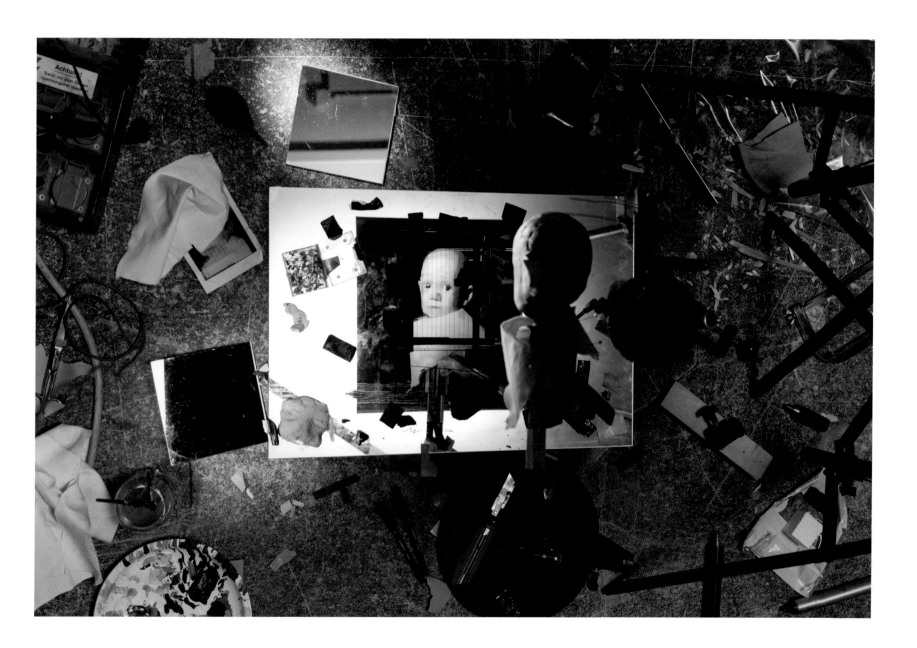

Harold Edgerton (1903–1990), Professor of Electrical Engineering at the Massachusetts Institute of Technology, first became fascinated with stroboscopy during his postgraduate studies; he went on to pioneer high-speed photography and the use of electronic flash. In addition to his scientific work – he also developed side-scan sonar technology with Jacques Cousteau, and invented high-speed cameras for use by the US Atomic Energy Commission during atomic bomb tests – Edgerton was renowned for his aesthetic sensibility, and for creating images that revealed the beauty of the visual world beyond human perception. *National Geographic* magazine dubbed him 'the man who makes time stand still'. Perhaps his best-known work is 'Milk Drop Coronet'. Made in 1957, it is a very simple photograph – a milk drop striking a thin layer of milk on a flat surface – but it demonstrates one of photography's compelling qualities as a medium: taking a humble, everyday moment and raising it to one of delicate yet dramatic beauty in a fraction of a second.

Making of 'Milk Drop Coronet' (by Harold Edgerton, 1957), 2016

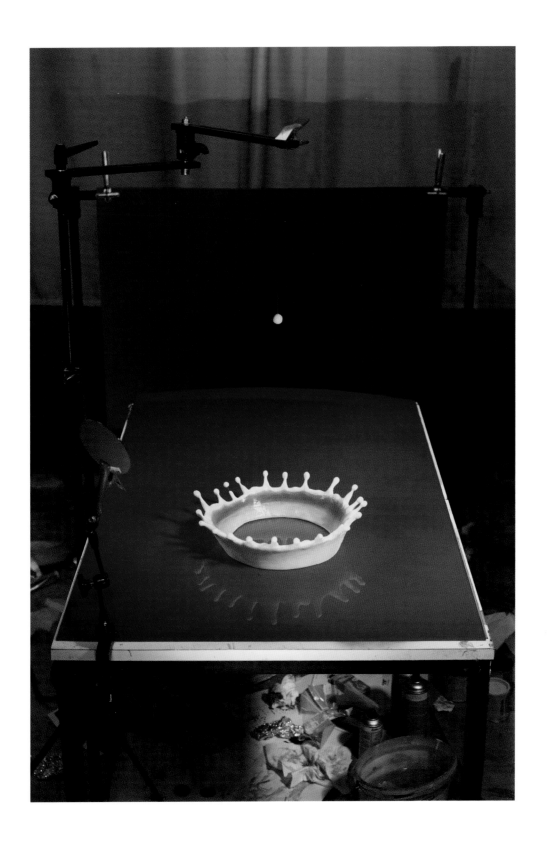

Ansel Adams (1902–1984), a native of California, first visited Yosemite in 1916 on a family expedition. He returned every year thereafter until his death. While earlier photographers – notably Carleton Watkins in the late nineteenth century – had captured the grandeur of the Yosemite landscape, Adams is most indelibly associated with it. 'Moon and Half Dome', taken in 1960, is one of his greatest works, representing a technical tour de force. Photographing the moon in the sky without it becoming a flat white disc is challenging. Balancing that exposure against a surrounding landscape is even more difficult. But while the image may appear to have been carefully planned, it was in fact the result of the photographer spotting an opportunity and making the most of it. Driving through the national park on a winter evening, Adams saw the gibbous moon rising at the same time as the setting sun was casting long shadows onto the rock-face of the Half Dome formation. Working with a simple light meter and careful filtering, he was so familiar with his renowned 'Zone' system that he was able to anticipate the correct exposure. He shot three frames, took notes, packed his Hasselblad and tripod back into his car, and drove on.

Making of 'Moon and Half Dome' (by Ansel Adams, 1960), 2016

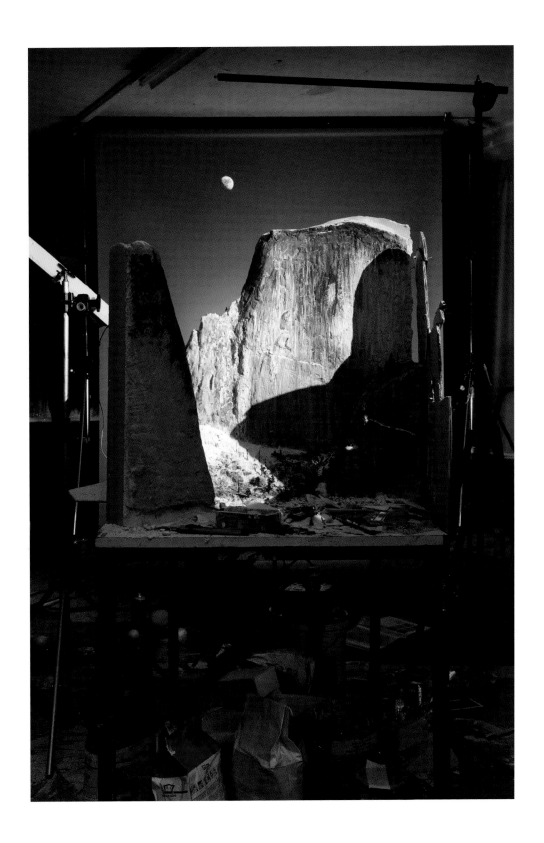

On the morning of 22 November 1963, the Russian-born dressmaker and amateur photographer Abraham Zapruder (1905–1970) made his way to Dealey Plaza, intending to film the motorcade that would carry President John F. Kennedy and his wife Jackie through downtown Dallas. Zapruder took with him his 8mm Bell & Howell Zoomatic movie camera. The 26-second film he ended up shooting – 486 frames on Kodachrome II colour safety film – turned out to be the most momentous home movie ever made. It captured the instant that one bullet struck President Kennedy in the back, and then a second exploded the side of his head. Frame 371 shows Jackie reaching across the back of the presidential limousine, and Secret Service agent Clint Hill climbing desperately onto the car. The film was developed later that day at Eastman Kodak's processing plant in Dallas: Zapruder kept the original and one copy, and two further copies were passed to the Secret Service. The following day, Zapruder sold the film rights to *Life* magazine, on condition that Frame 313, which showed the gruesome fatal shot, would not be reproduced. The original film and camera now reside in the US National Archives.

Making of 'Frame 371' (by Abraham Zapruder, 1963), 2015

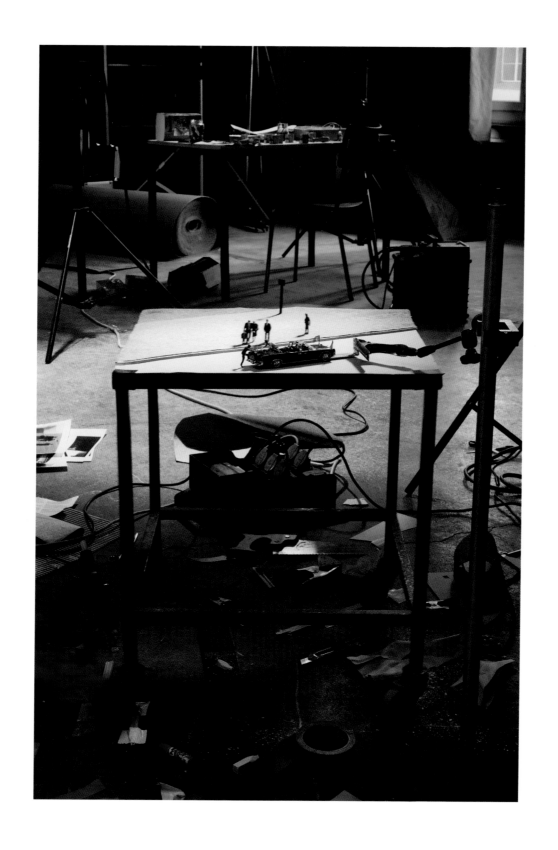

On 1 October 1949, Mao Zedong, leader of the Chinese Communist Party, proclaimed the founding of the People's Republic of China. For decades he wielded unlimited power, aggressively suppressing any dissent and launching the 'Great Leap Forward' in which sweeping changes were made to Chinese society. By 1966, the 72-year-old Mao was beginning to consider the future and the legacy he would leave behind. In July of that year, he therefore decided to show the world that he was in robust health and fit for any challenges that lay ahead. In what became the most powerful publicity stunt in Chinese history, he entered the Yangtze River at Wuhan, surrounded by bodyguards, and was reported to have led thousands of followers in a swim. The picture of that scene, taken by Qian Sije, turned out to be a propaganda coup, reinvigorating the image of the leader and tightening his grip on power.

Making of 'Mao Swimming in the Yangtze' (by Qian Sije, 1966), 2016

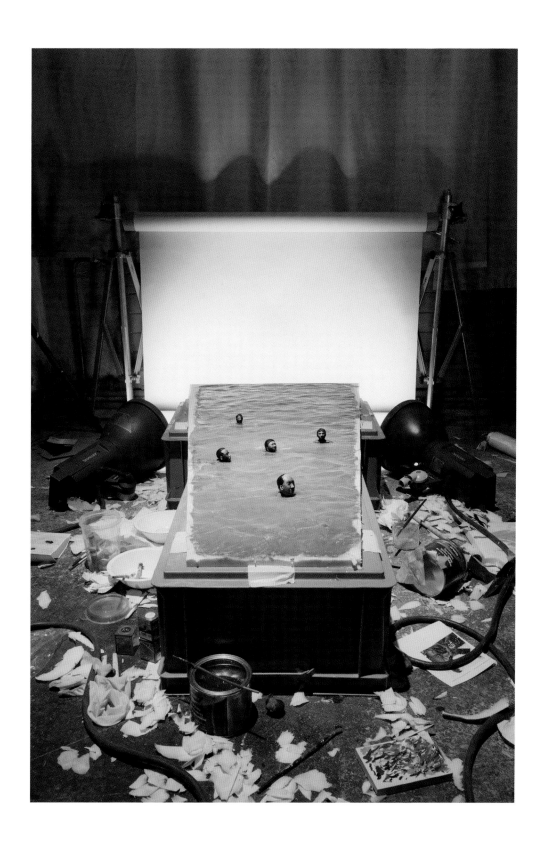

At the Summer Olympic Games held in Mexico City in 1968, the American sprinters Tommie Smith and John Carlos won gold and bronze respectively for the 200-metre event. Standing on the medal podium, they waited for 'The Star-Spangled Banner' to begin, then each bowed his head and raised a black-gloved fist in the traditional gesture of 'Black Power'. By expressing their wish for all human beings to be treated equally, the athletes were making the most overt political statement the Olympics had ever seen. The photographer John Dominis (1921–2013) captured the moment. His image showed that Smith had removed his shoes, symbolizing black poverty. It also showed that the Australian silver medallist, Peter Norman, had chosen to wear a Human Rights badge in an act of solidarity. History relates that it was also Norman who suggested that Smith share his gloves, Carlos having left his own pair at the Olympic Village. Dominis later admitted to *Smithsonian* magazine: 'I didn't think it was a big news event…. I hardly noticed what was happening when I was shooting.' However, the protest was met with widespread outrage in the United States, and the pair were expelled from the Olympic Village. They remained unrepentant. 'We knew that what we were going to do was far greater than any athletic feat,' Carlos said. Smith noted: 'We were just human beings who saw a need to bring attention to the inequality in our country.'

Making of 'Black Power Salute' (by John Dominis, 1968), 2017

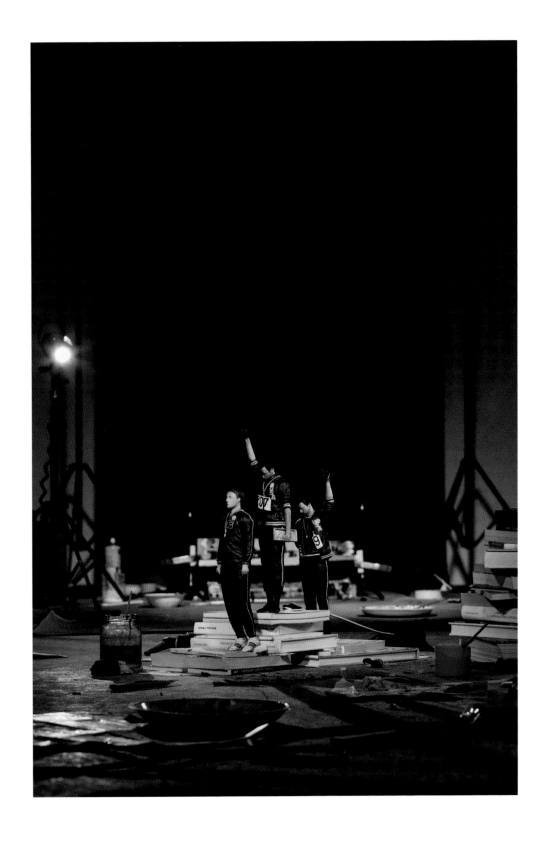

AS11-40-5878 is the NASA frame reference number for one of the defining images of the Apollo moon landings. The photograph was taken by Edwin 'Buzz' Aldrin (b. 1930) during surface EVA (extravehicular activity) on 21 July 1969. The purpose of the photographs taken during the Apollo 11 expedition was, apart from the flag salutes, mostly scientific. The image of Aldrin's bootprint pressed into the lunar soil – while being the photograph that readily communicated to those back on Earth the 'giant leap for mankind' and the exhilaration of the moon landings – was, in fact, the visual documentation of an experiment to test the compressibility of the moon's surface in response to human footprints. Aldrin and his commander, Neil Armstrong, were equipped with three Hasselblad 500EL cameras for the mission, one of which – known as the 'Data Camera' and fitted with a specially commissioned f5.6/60mm Zeiss lens – was used to capture the image. While it seems entirely monochrome in appearance, it was actually shot on colour film.

Making of 'AS11-40-5878' (by Edwin Aldrin, 1969), 2014

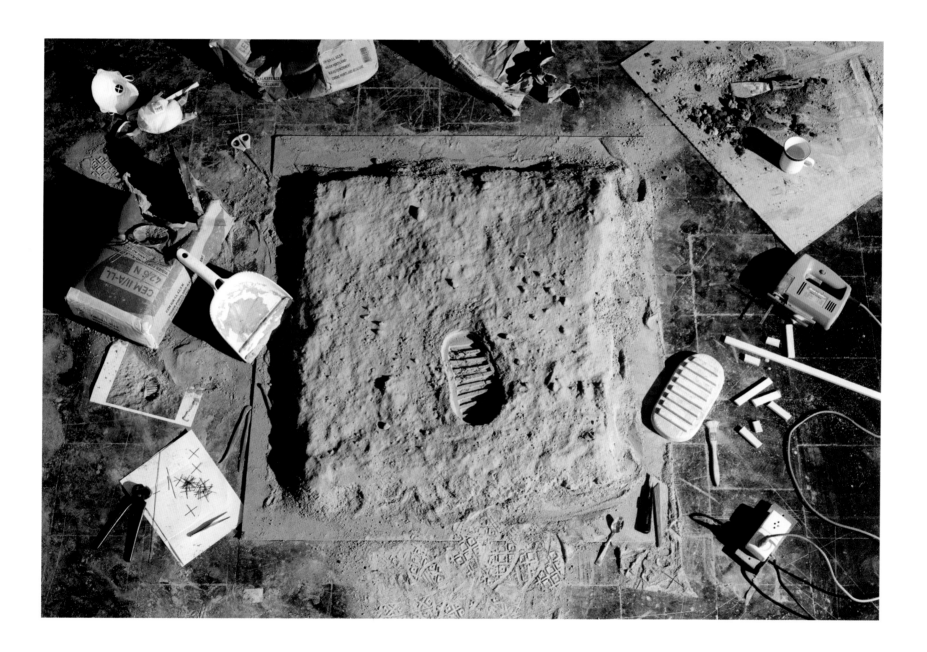

In 1972, Germany hosted the Summer Olympic Games for the first time since the ignominious Olympics of 1936, held under the Nazi regime. The country now wished to present a positive, optimistic impression (its official Olympic motto was 'die heiteren Spiele', or 'the cheerful Games'). Security was relatively lax as part of this open spirit. On 5 September, eight Palestinian members of the Black September terrorist organization broke into the Olympic Village in Munich, taking nine Israeli athletes and coaches hostage, and killing a further two who resisted. The siege – which was televised to a global audience – lasted 21 hours. During that time, Associated Press photographer Kurt Strumpf took a chilling image of one of the terrorists, faceless in a balaclava, standing on a balcony. The militants demanded the release of over two hundred Palestinian prisoners in return for the hostages' lives. Israel refused to negotiate, and during a botched rescue attempt by the German authorities on the runway of a nearby airbase to which the terrorists and hostages had been transferred, all nine Israelis were murdered. Strumpf's photograph of the masked man, shattering the peace of what should have been a harmonious and joyous event, came to epitomize the horrors of terrorism.

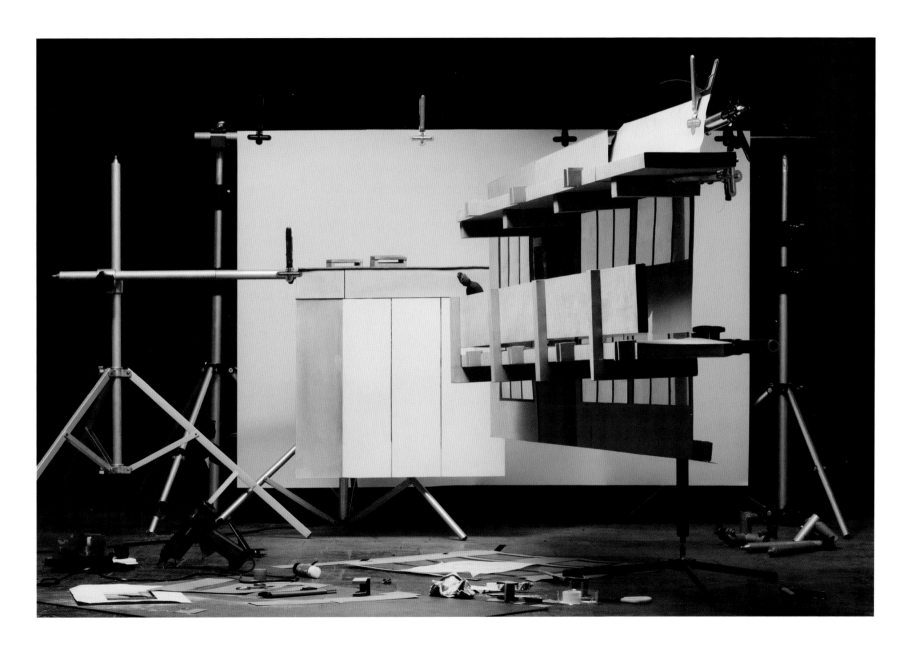

William Eggleston's (b. 1939) celebrated image is untitled, but has become known by two names: 'The Red Ceiling' and, after its location and year, 'Greenwood, Mississippi, 1973'. Eggleston is credited with bringing colour photography – which was previously seen as 'commercial', and the preserve of advertising and fashion photography – into the sphere of the art world and museums. Today, prints of 'The Red Ceiling' can be found in the collections of the Museum of Modern Art in New York and the J. Paul Getty Museum in Los Angeles. The photograph was originally reproduced as a dye transfer print, a process Eggleston discovered in 1973 while looking through a photography lab price list. Dye transfer printing was the most expensive option of the time – 'the ultimate', in the photographer's view. 'When you look at the dye it is like red blood that's wet on the wall.... A little red is usually enough, but to work with an entire red surface was a challenge.' Eggleston has never been wholly satisfied with any reproduction of the photograph in a book or by any means other than dye transfer.

Making of 'Untitled' (by William Eggleston, 1973), 2016

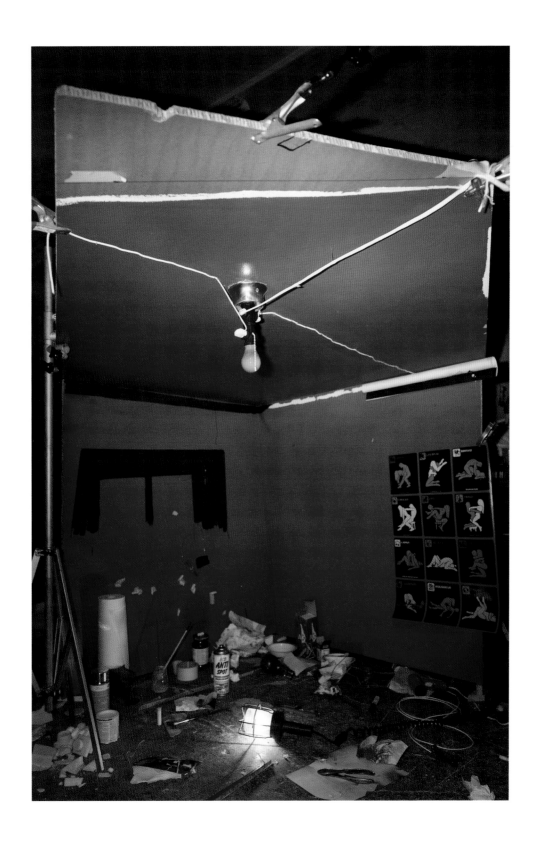

The Vietnam War began in 1955, and was fought between North Vietnam (supported by the Soviet Union, China and other Communist allies) and South Vietnam (supported by the US and other anti-Communist members of the South East Asia Treaty Organization). It ended on 30 April 1975, when Saigon, capital of South Vietnam, was captured by the North Vietnamese. Prior to the capture, nearly all American civilian and military personnel were evacuated, as were thousands of South Vietnamese deemed 'at risk'. This culminated in 'Operation Frequent Wind', a final-phase helicopter evacuation organized by US forces. On being alerted to the arrival of a helicopter above a CIA building at 22 Gia Long Street, Dutch photojournalist Hubert van Es (1941–2009) grabbed the longest lens he could find in the United Press International's office – a 300mm – and photographed the desperate line of people scrambling up a ladder in an attempt to board the Air America Huey. The helicopter took off with a dozen or so on board, which was more than recommended. 'After shooting about 10 frames,' van Es recalled, 'I went back to the darkroom to process the film and get a print ready for the regular 5 pm transmission to Tokyo from Saigon's telegraph office.' The next day, Saigon fell.

Making of 'Fall of Saigon' (by Hubert van Es, 1975), 2015

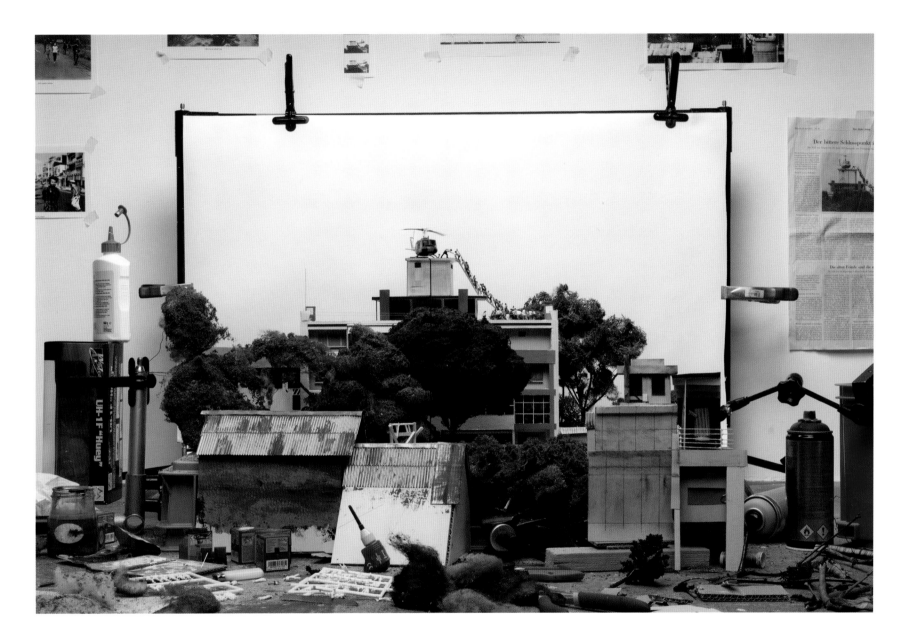

On the night of 21 September 1979, British photographer Pennie Smith (b. 1949) was photographing The Clash performing at New York's Palladium as part of their 'The Clash Take the Fifth' US tour. Smith was well known for photographing bands, and had made her name working as a staff photographer for *NME* magazine. During the concert, the generally mild-mannered bassist Paul Simonon became irritated by the quietness of the audience, who were not allowed to get up out of their seats, and began smashing his Fender Precision bass against the stage floor. When, three months later, the band came to select an image for the cover of their album *London Calling*, lead singer and rhythm guitarist Joe Strummer was in favour of featuring Smith's photograph. She demurred, as the image was slightly out of focus (she had been backing away from Simonon as she photographed him, to avoid being hit). Strummer convinced her that the shot should be used. In 2002, *Q* magazine named it the 'Greatest Rock 'n' Roll Photograph of All Time'. The remains of Simonon's smashed bass are held in the permanent collection of the Rock & Roll Hall of Fame in Cleveland, Ohio.

Making of 'Paul Simonon at the New York Palladium, September 21st, 1979'
(by Pennie Smith, 1979), 2016

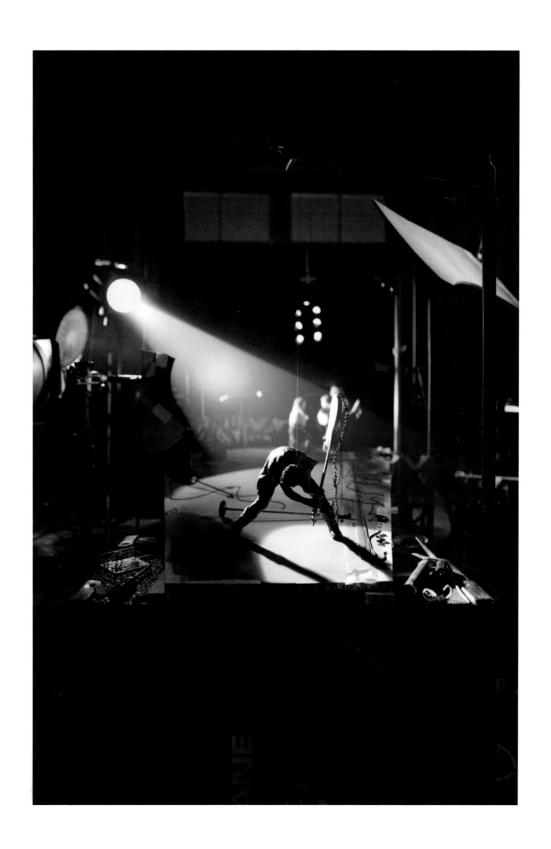

On 28 August 1988, at the US base of Ramstein in West Germany, the American Air Force put on an air show. Many of the 300,000-strong audience were US servicemen and their families; German civilians were also in attendance. As part of the display, the Frecce Tricolori aerobatic demonstration team from the Italian Air Force staged a low-level fly-through, in which two groups of jets were to combine to make a heart-shaped formation, with a lone aircraft flying between them and 'piercing' the heart. This complex, high-speed manoeuvre required split-second timing. On this occasion, it went disastrously wrong. The solo jet sliced into a second plane, and this in turn clipped a third, which crashed into a medical evacuation helicopter waiting on the tarmac. A fireball of disintegrating fuselage and aviation fuel then hurtled towards the crowd. All in all, the disaster left 70 dead and 346 seriously injured, mostly with severe burns. The carnage was captured on dozens of cameras, including Martin Füger's, which later helped investigators piece together the events of what was – at the time – the world's worst air show accident.

Making of 'Ramstein' (by Martin Füger, 1988), 2014

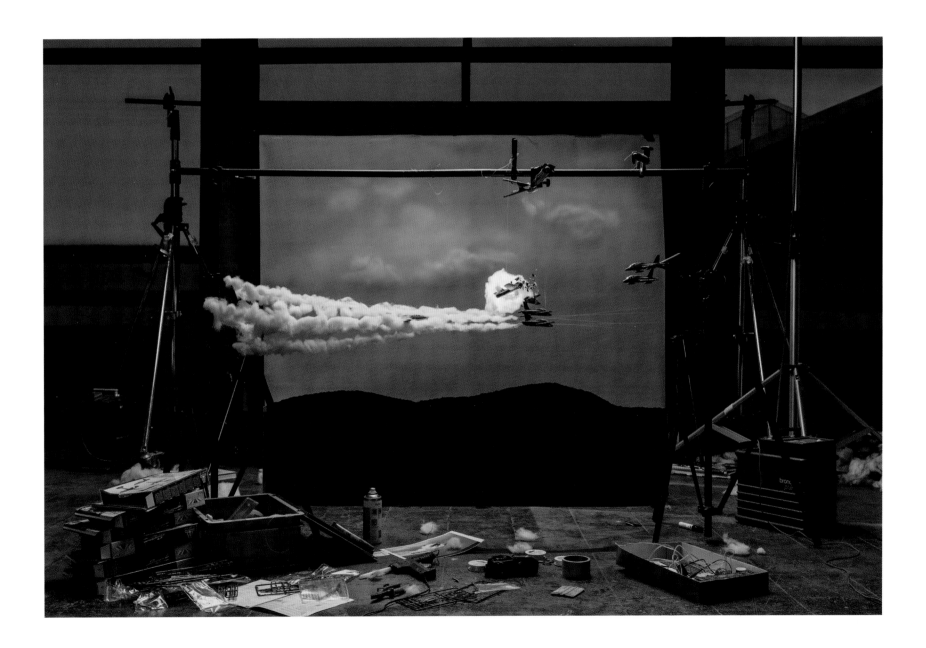

On 24 March 1989, having taken on board a full load of Prudhoe Bay crude oil, the single-hull tanker *Exxon Valdez* left the trans-Alaska pipeline terminal of Valdez. A few miles from port, the ship met with disaster when it ran aground on Bligh Reef in Prince William Sound. Seattle-based photographer Natalie B. Fobes was one of the first to arrive on the scene. The remote location – a habitat for salmon, sea birds, harbour seals, sea otters and killer whales – was accessible only by helicopter, plane or boat. Approximately 11 million US gallons of oil had spilled, and would eventually cover 11,000 square miles (28,000 km^2) of ocean and 1,300 miles (2,100 km) of coastline. On 25 March, Fobes noted in her journal: 'Got my first look at the spill. I can't believe it. The fumes are nauseating as we flew at 1500 feet. Even at this altitude I can't see the edge of the spill. How in the hell are they going to clean this up.' Her photographs for *National Geographic* magazine captured the spreading devastation, against the serene backdrop of the Chugach Mountains. Fobes's testimony and her images of one of the worst environmental disasters in US history would later be used in federal and state courts.

Making of 'Exxon Valdez' (by Natalie B. Fobes, 1989), 2016

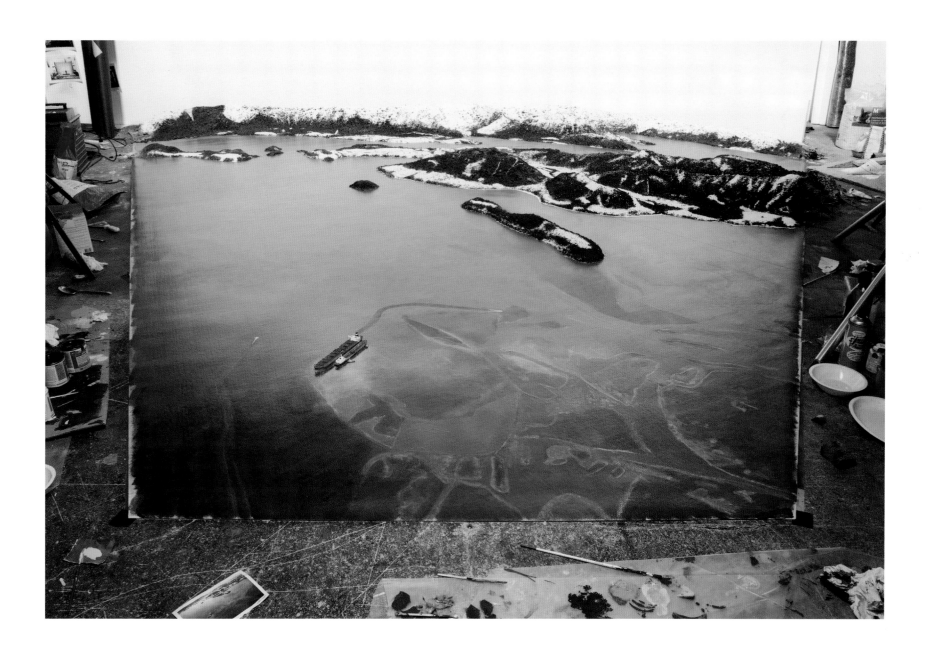

'Rhein II' was created in 1999 by the German photographic artist Andreas Gursky (b. 1955). Gursky is renowned for his large-scale, highly detailed works depicting the landscape, architecture and industry of the modern world. A member of the Düsseldorf school of photography (he was taught by Bernd and Hilla Becher, along with his contemporaries Candida Höfer and Thomas Struth), he makes work that is typically immersive, expansive and richly complex. However, 'Rhein II' is at first glance a relatively simple, abstract piece. It depicts a stretch of the Rhine just outside Düsseldorf, and was created using Gursky's usual process – photographing with a large-format camera before scanning the film so that the image can be digitally manipulated. With 'Rhein II', a factory on the far side of the river and people walking on the banks were removed, leaving the water as a single horizontal band between two green fields under an overcast sky. It was produced in an edition of six prints, and the first (and largest) print in the series came to wide public attention when, in November 2011, it was auctioned at Christie's in New York for $4.3 million, which made it the world's most expensive photograph.

Making of 'Rhein II' (by Andreas Gursky, 1999), 2012

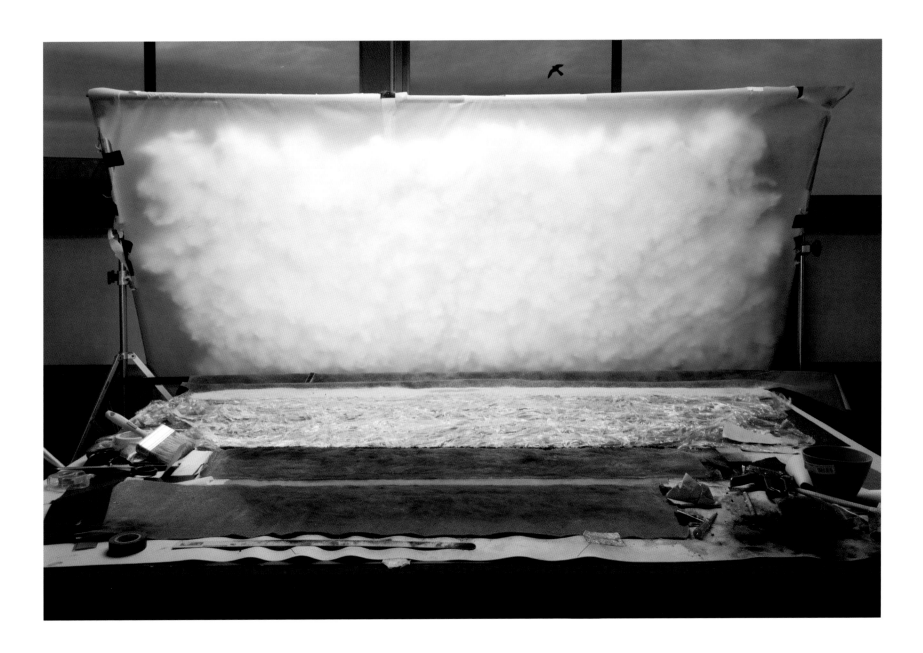

Air France Concorde Flight 4590 was scheduled to fly from Paris to New York on the afternoon of 25 July 2000. Two minutes after take-off from Charles de Gaulle airport, the plane crashed into a hotel in nearby Gonesse, killing all one hundred passengers on board (mostly German tourists en route to New York for a cruise), nine crew and four hotel workers. Amateur photographer Toshihiko Sato captured the appalling moment of departure, with fire raging from the doomed plane's engine on the left wing. Investigations concluded that a poorly installed strip of titanium alloy had dropped off a Continental Airlines DC-10 that had been on the runway shortly before the Concorde. This debris punctured a tyre and caused a fuel tank to rupture; leaking fuel may then have been set alight by an electric arc in the landing gear bay. There was no way the cockpit crew could accelerate, halt or climb. A criminal investigation led to Continental Airlines being fined and ordered to pay Air France 1 million Euros, plus a share in the 100 million Euro compensation paid to the victims' families; the mechanic responsible for the strip installation error was given a suspended sentence. Three years after the crash, civil supersonic flights were ended.

Making of 'Concorde' (by Toshihiko Sato, 2000), 2013

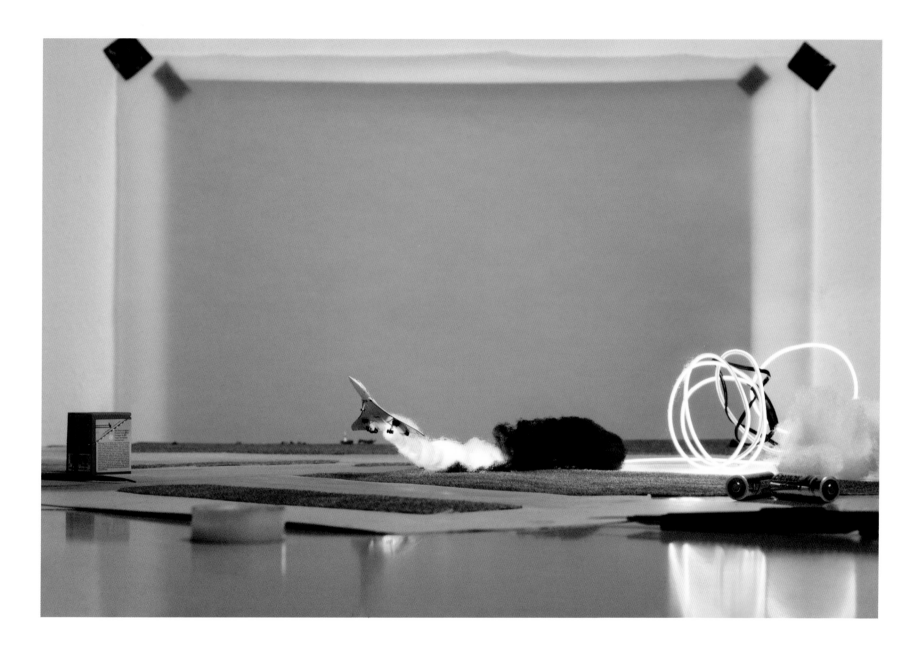

The September 11 attacks on the United States were coordinated by the Islamist terrorist group al-Qaeda. Nearly 3,000 people were killed, with thousands more injured. Major landmarks – including the World Trade Center in New York – were targeted. A helicopter piloted by Arthur Anderson was first on the scene, and footage from the chopper was aired live on CNN, Fox News and countless other channels worldwide. The pilot recalled: 'I was flying what we at the base call "the radio ship" (N8BQ). On board was Brian McKinley reporting for 1130AM Bloomberg Radio and Tom Kaminski for 880AM CBS Radio. Sometimes we are required to do cut-ins for WABC-TV in New York, so we were also carrying television-broadcasting equipment....' It was late in the shift and the team was heading back to base when Anderson saw the first plane – hijacked American Airlines Flight 11 – fly over lower Manhattan and crash into the North Tower of the World Trade Center. 'I flew southbound toward the towers. We knew we had to go and cover this story. Brian and Tom … were broadcasting and they started rolling the camera.... The first pictures the world saw were taken from our ship.' They then watched as the second plane – United Airlines Flight 175 – crashed into the South Tower. President George W. Bush responded with military action; in 2011, the mastermind, Osama bin Laden, was finally tracked down and killed.

Making of '9/11' (by Tom Kaminski, 2001), 2013

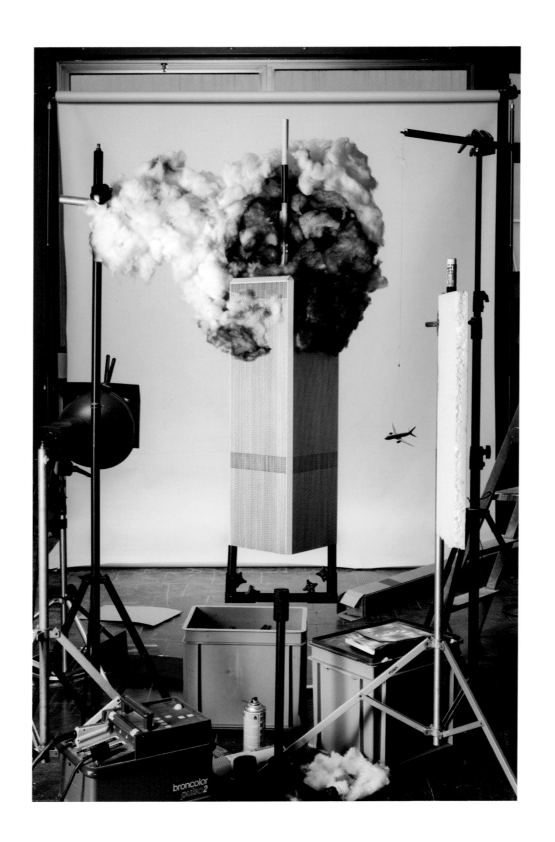

From 2003 to 2006, the prison complex of Abu Ghraib, located west of Baghdad, was used for detention purposes by the Iraqi government and the US-led coalition forces who were then occupying the country. In May 2004, an article was published in *The New Yorker* magazine reporting torture, mistreatment and humiliation of Iraqi prisoners at the facility. The story included a photograph of a hooded man forced to stand on a narrow cardboard box, his arms outstretched and his fingers wired with electrodes. The now-infamous photo was taken by US Army Staff Sergeant Ivan Frederick. Approximately three minutes later, Specialist Sabrina Harman (b. 1978) took a similar shot. Harman was one of several guards to be charged with abuse of Abu Ghraib detainees. The man under the hood was eventually revealed to be Ali Shalal, an Islamic education lecturer. He survived, and – in the name of all those who had been tortured to death – supplied testimony confirming the atrocities that had been committed at Abu Ghraib, including the fact that he had been electrocuted on multiple occasions. Harman received a bad conduct discharge and was sentenced to six months' imprisonment.

Making of 'Abu Ghraib' (by Sabrina Harman, 2003), 2014

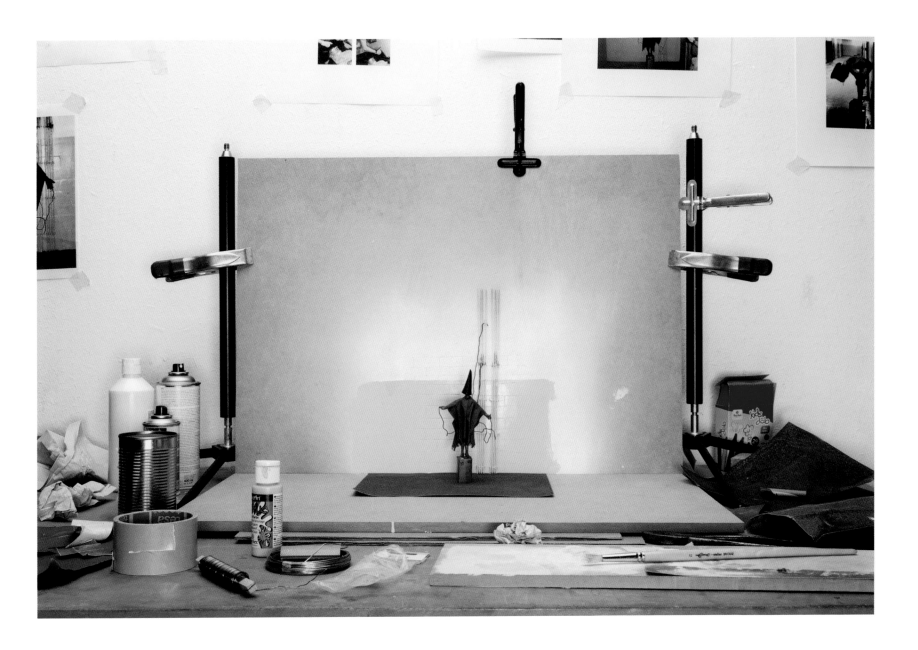

One of the largest earthquakes ever recorded struck the Indian Ocean on 26 December 2004. Its epicentre was off the coast of Indonesia, but it triggered further earthquakes and a series of tsunamis that devastated entire communities hundreds of miles away. As the ocean floor was violently uplifted, billions of tons of sea water were displaced, creating waves that travelled at speeds of up to 500 miles per hour (800 km/h) and hit shorelines at heights of up to 50 feet (15 m). One bystander made a video of a tidal wave breaching a hotel wall in the Malaysian state of Penang: this amateur footage was picked up by the Reuters news agency. In all, some thirteen countries were affected, the worst being Indonesia, Sri Lanka, India and Thailand. Over a quarter of a million people lost their lives, and some two million were made homeless. The disaster prompted a worldwide humanitarian response that included the provision of short-term solutions such as water purification tablets, medical supplies and temporary housing, as well as billions of dollars in aid. An early warning system has now been set up between the countries that surround the Indian Ocean.

Making of 'Tsunami' (by unknown tourist, 2004), 2015

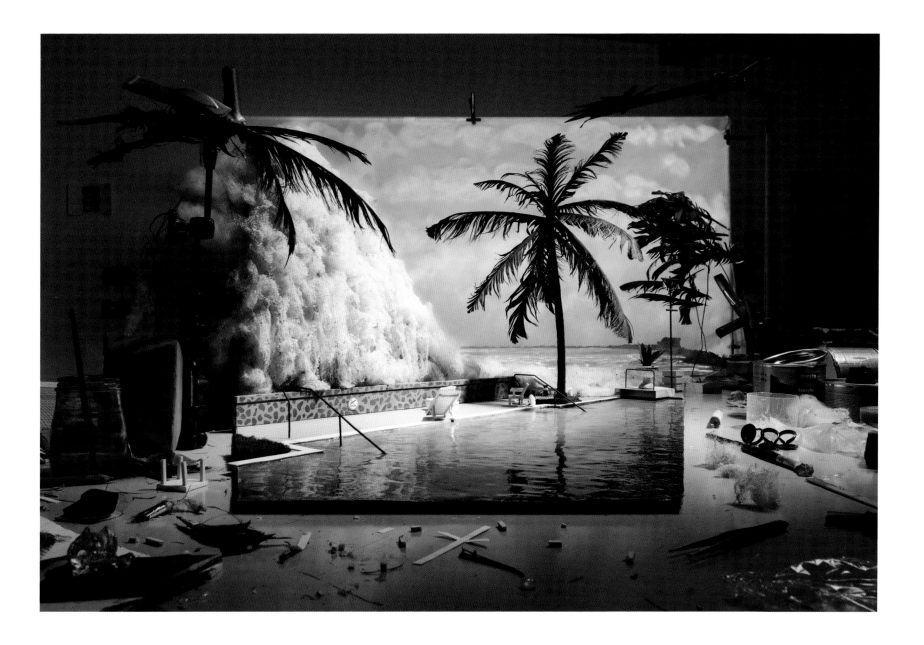

CONSTRUCTIONS

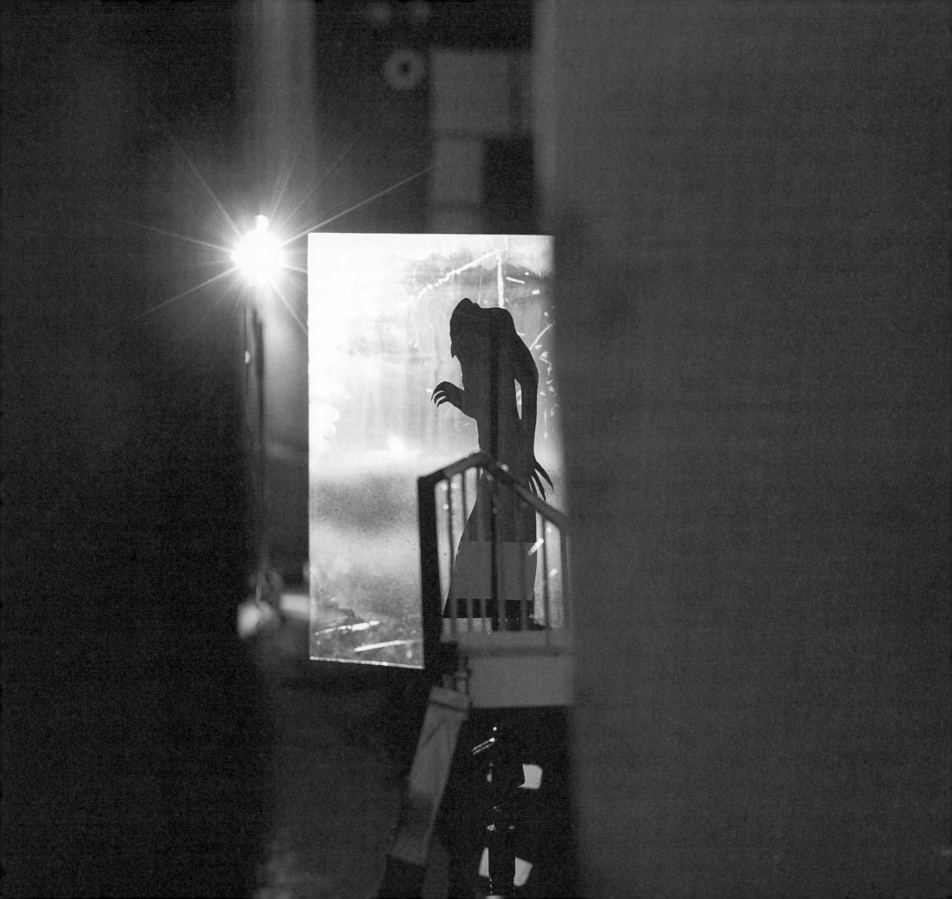

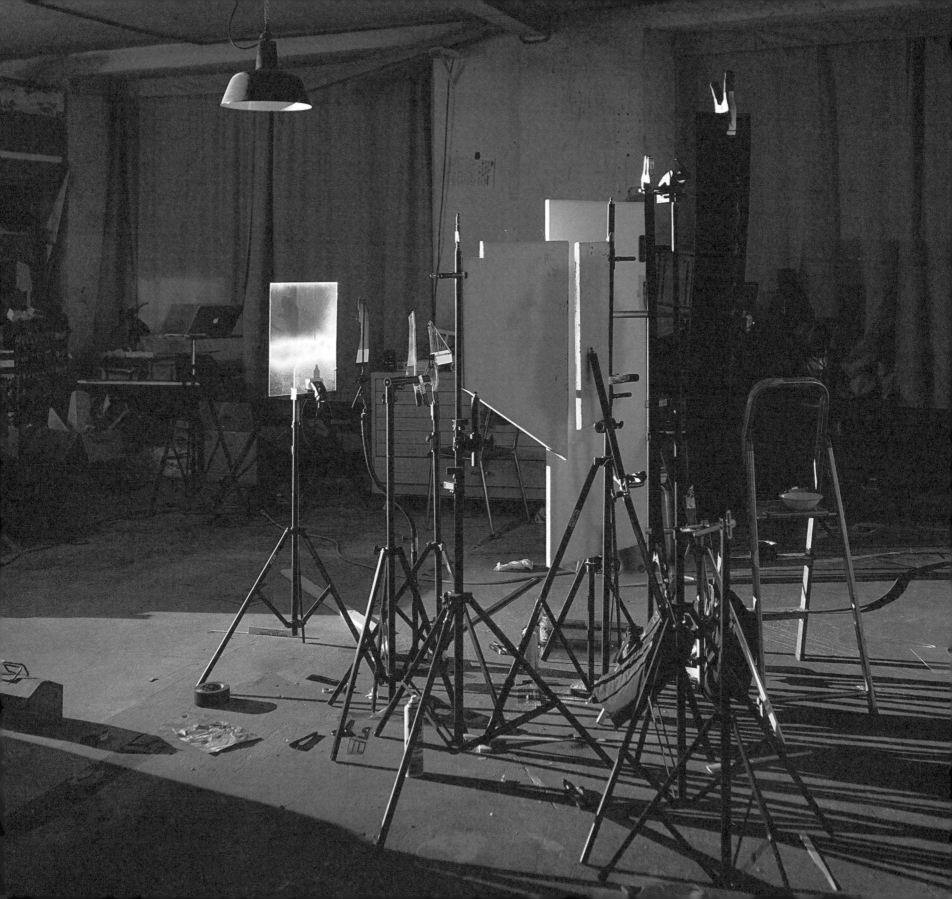

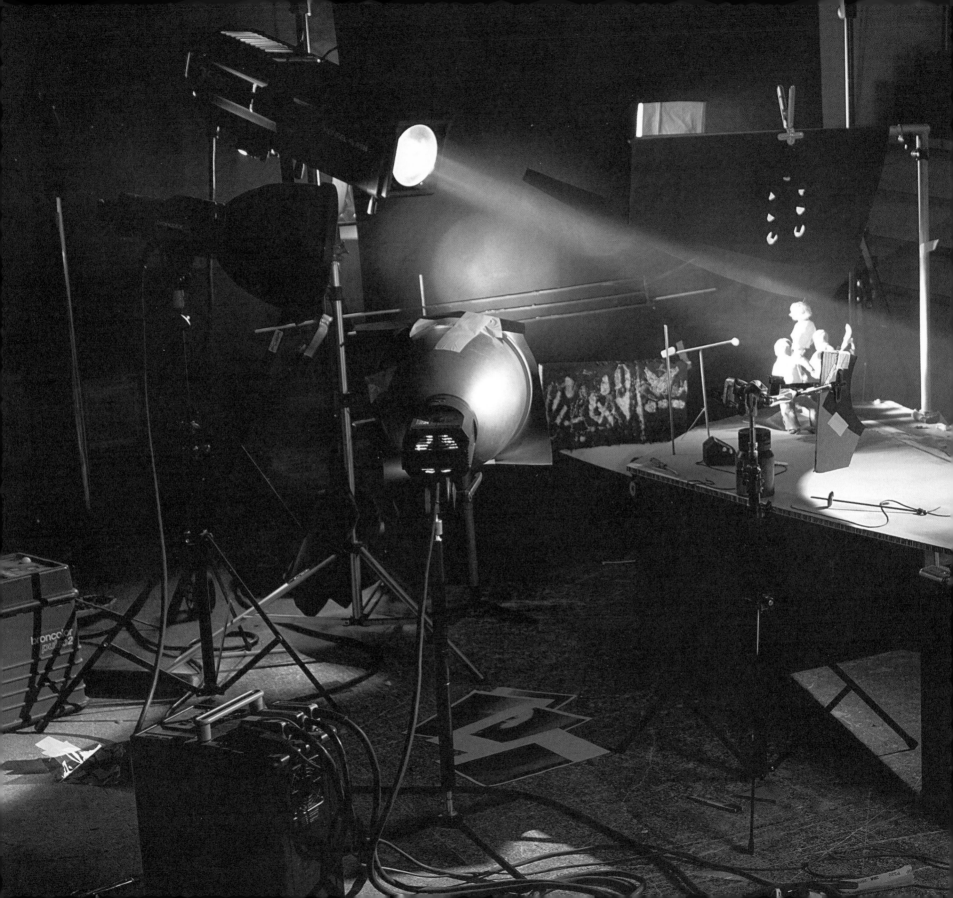

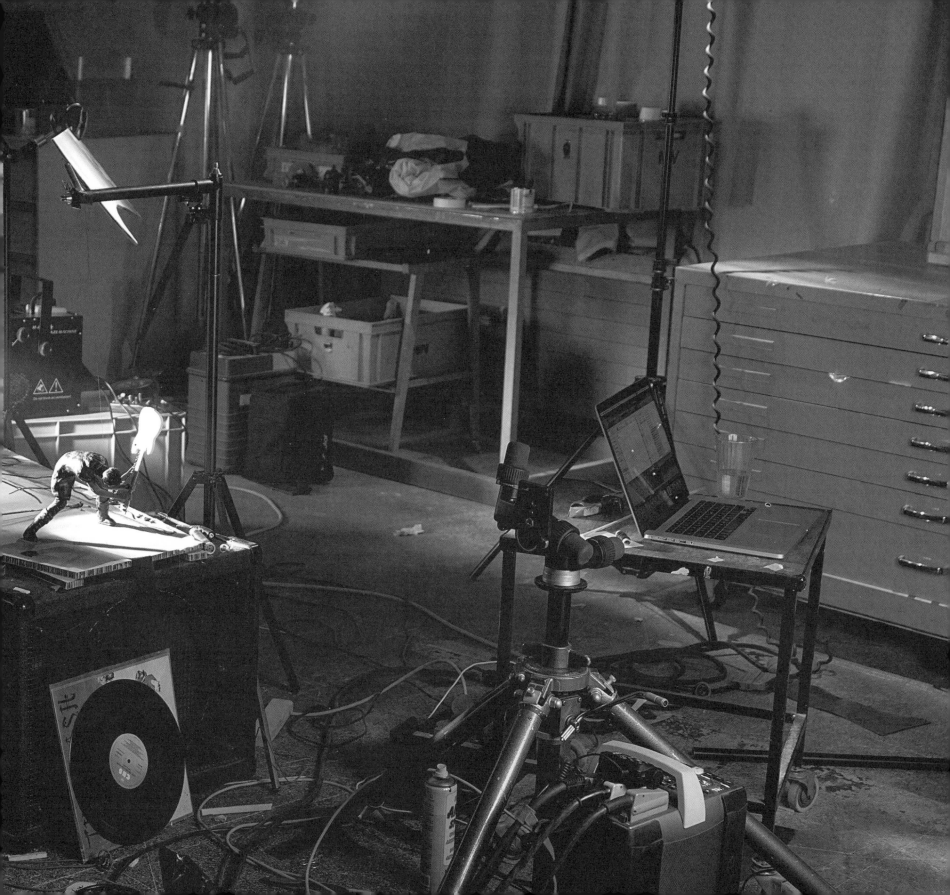

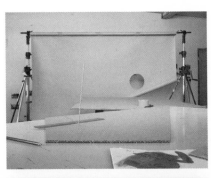
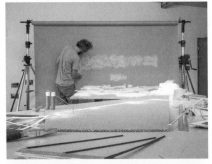
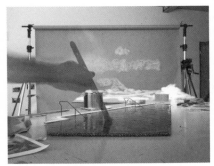
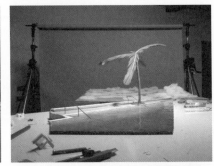
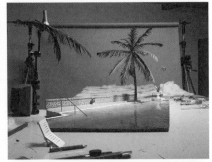
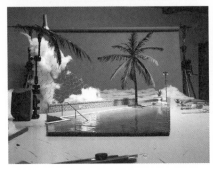
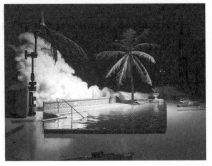
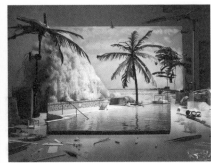

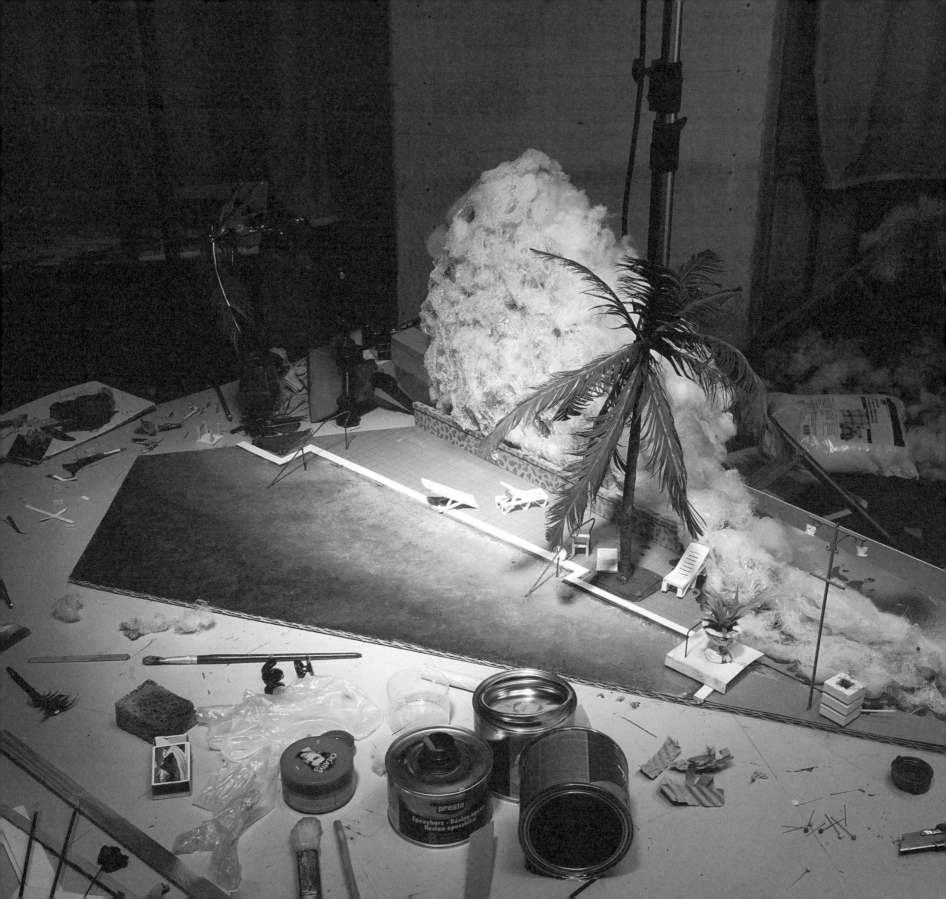

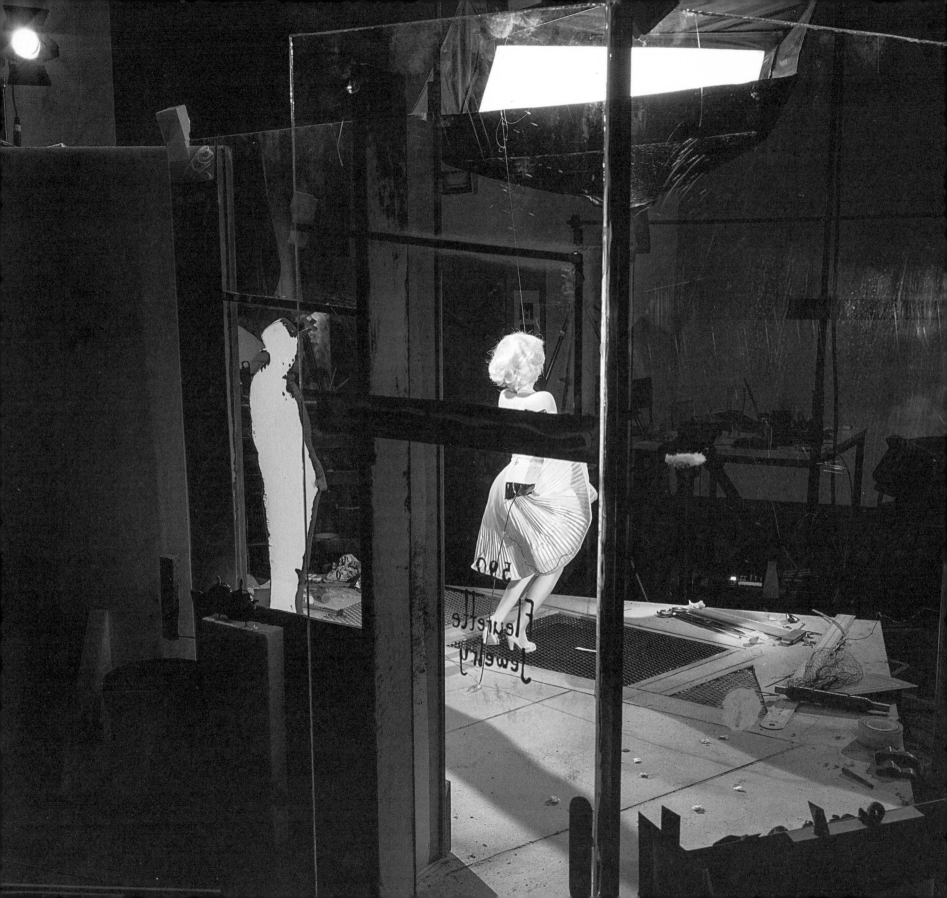

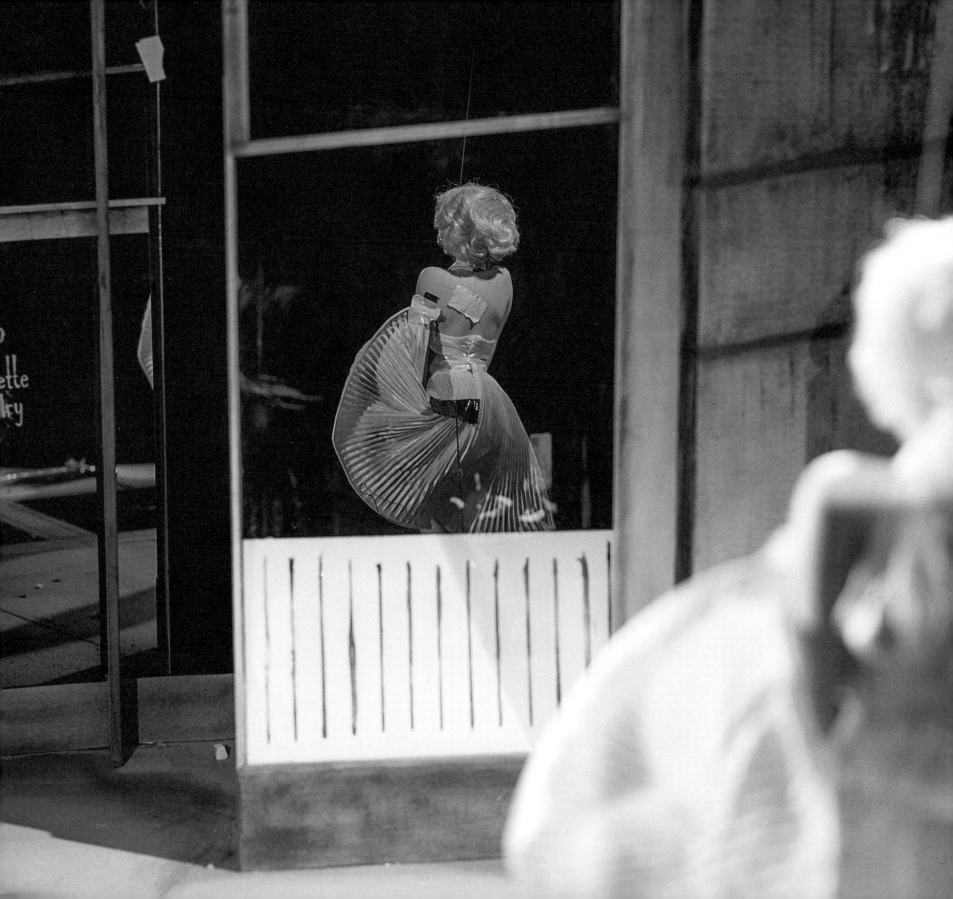

INTERVIEW WITH WILLIAM A. EWING

WE: Let's start at the beginning. And that implies two things: first is the concept, and second the partnership.

JC: We met at art school in Zurich, and I think we started working together at the end of our studies, in 2005 or 2006. During our studies we had some projects together, but we really started working together for our graduation project, and we also wrote our theory text together, and that was about 'art couples'.

AS: It was a new experience for us to work with somebody else, because a photographer is....

WE: Individualistic, right? And was there one of these couples that particularly influenced you?

AS: Fischli/Weiss. We also did an interview with them for our diploma thesis and, even today, all the time, Fischli/Weiss always come back to us.

WE: You mean, people refer to them in talking about your work, or you keep coming back to them as inspirations?

AS & JC: Both.

AS: One part of our partnership is, I think, simply fun. A lot of people say that with our images it seems like we had fun doing them … and it's true.

WE: Is everything planned meticulously beforehand, or, as you construct, do you think, 'This isn't working, let's try this, or that?' How much of the process is pre-planning, and how much is problem-solving as you proceed?

JC: There's always a lot of pre-planning. When we're looking for images we want to reconstruct, we first have to be sure we'll succeed. We don't want to work two months on an image and then find out it's just too difficult to make it happen.

WE: What factors signal that it's not working? How do you know to pull the plug early in the process?

JC: Take reconstructing figures of people. It's really difficult if you want authenticity. If you have two or three people in an image it might work, but if you have hundreds of people it's not going to work. Also a close-up of a face is particularly difficult.

AS: We're quite good at pre-planning, as Jojakim says, and that's why there's only one image of the series that failed. In general, doing photography in a

partnership, it's always: one has an idea, the other one listens to the idea and has an image in his mind, but at the very beginning both those images are not one and the same, so before we start we always have to be sure that we have the same image in our mind. It's often like playing ping-pong. One of us has an idea, the other one says, 'Yeah, I like this, and this part of the idea, but what if we do it like this?' And that's how an idea gets to the pre-planning and then through to the final image.

WE: It reminds me a bit of the Vik Muniz pictures where he went from memory, tried to reconstruct famous photographs, and sort of got it wrong, because he thought he had it in his mind…. That's interesting, what you describe, having to align or calibrate each of the images in your mind. But when you have an idea of recreating a new iconic image, you're actually probably showing each other that photograph, no?

JC: Yes, of course. Sometimes it's an unknown image for the other one.

WE: And do you reject a fair number of these from each other?

AS: I think we both have personal favourites, and therefore it's normal that images are rejected.

WE: And do the favourites remain after you've made them? Are they still the same favourites?

AS: Good question! [Laughter]

JC: They probably change. Maybe I had one favourite a year ago, maybe now it's a different one.

WE: I notice often with photographers their most recent work is their favourite. I often think it's because they remember the effort to make it, and so on. It's very hard to criticize the latest work; they're very defensive because they've just invested money and time – they've suffered! So, once you've finished an image, is your emotional connection different from what it was at the beginning? If we take the '9/11' picture, it was a video still, right? So you saw the video, or did you see the still first?

AS: I think we both saw the video on the news as it was happening. But our visual memory is based on the still.

WE: What date did you make '9/11'?

JC & AS: 2013.

WE: OK, so the horror of the event is less immediate. You guys were kids, right, when it happened?

AS: Twenty-one.

WE: Kids, right, OK. So for you it's a historical event. Once you've completed the image, do you feel that you have a different relationship to that historical event? Has it changed? The concentration you have to put into a picture, and the planning, does it change your feeling about that event?

AS: I think, as you said, there's always a period between when the image was made and when we make our reconstruction. I think that's also the reason we don't do any recent icons, like the World Press Photo of the last year. Time has not settled for those images.

WE: Of course, and we don't know what the iconic pictures are yet either.

JC: I don't know if there is any iconic image any more. I mean, for 9/11 there's more than one image that's famous, but still not so many at the time. But, take the tsunami, there are so many pictures: everyone had a smartphone and was making images of this catastrophe. So we have to select one image where we think, 'OK, it might be interesting for us to do and we can do it', but it's not like the *Hindenburg* or Tiananmen events: if you hear those words, only a few images come to mind.

WE: As part of your pre-planning, you have to learn about the event, don't you? I imagine you have to go quite in-depth to reconstruct the materials, asking, 'Well, what was this material, actually?' – maybe in the cloud of dust, the chemicals, the asbestos, the I-don't-know-what?

AS: Yes, we always say we're like forensic detectives. We have to go quite deep.

WE: Do you read about it?

JC: Yes, we read about it. For the Munich Olympics image, we had to study how the building really looks; not only the original image of it, but all the surroundings. There's lots of research we have to do.

WE: Do you ever go to the site of these events?

JC: No, we always stay in our studio.

AS: And when we have an iconic image it's two-dimensional, but – remember – the event itself was three-dimensional; someone took an image, it became two-dimensional, then we make it three-dimensional again, and then we make an image also, so it's back again to two dimensions!

WE: This is interesting now, with all the 3D printing and virtual reality. Would you conceive of another stage, where you put headsets on and went 'into' the image; another step forward, so to speak?

JC: We haven't thought about virtual reality yet, but people ask us if we would work with 3D printers; like, to reconstruct objects. We don't think that's really interesting for us, because we like to try to do it with our hands, and also if you're doing it with a 3D printer, it's, I think, too perfect … too clean.

AS: Also it depends on the size of the image. It probably works differently when you're looking at a print on the wall compared to in a book.

WE: What's the wall-size that works best for you?

JC: It depends on the image. We have two different sizes: 70 × 105 cm [$27^1/_2 × 41^3/_8$ in.], and 120 × 180 cm [$47^1/_4 × 70^7/_8$ in.].

WE: Is your shooting always digital?

JC: Yes.

AS: And the good thing about those images is that they function very small on a smartphone, but also very big on a wall. If an image is on a wall, there are more layers – you can see how we painted the wall of this-and-this, and how we did the props. But the main thing is the frame around it.

WE: So you always have to decide how much information you want to give the viewer, like how you painted the wall, or something like that. When do you make those decisions? Behind that question is: what *cannot* be pre-planned?

JC: Almost everything in the studio we can control. I mean, we can't plan the weather when we're looking out of the window. But we can wait for the perfect weather once we've finished the set.

WE: But if you're using a new material to mimic something in the original and you think it's perfect, and then you use it and it's not perfect, what do you do?

JC: OK, take the water in any particular image. You can use more than one material. For the 'Exxon Valdez' image, it was really hard to do the water. We tried out different things, and in the end it was very much like painting.

AS: We always know where we want to go – we have the iconic image as a reference – but we don't know which materials we want to use. For example, we have an image from Robert Frank which we're starting now: one of us makes the wall, one makes the people. When we start, we discuss the materials, but it's always trial and error. The important thing is we always fix the camera in place first, so we can take a picture with a quick test and see if it's working or not, and then choose the right materials.

WE: Is that testing something you do continually? At many stages?

AS & JC: Yeah, yeah.

WE: Also now you've done forty or more pictures. Like theatre directors or set designers, if they've done forty plays then they know about all kinds of materials and get better and better at using them.

AS: Yes, we've learned a lot. If you look at the first images we did, there's a very big difference compared to what we do now.

JC: Take '9/11' – we'd probably do the cloud differently now. Or we'd do the water differently in Andreas Gursky's 'Rhein II' image. But we wouldn't do it over again, because for us it's the history of our work....

WE: Give me an example then, specifically, talking about the water, talking about the cloud. What did you do then, and what would you do differently now?

JC: If we were doing the clouds right now, we would try to do them softer. For '9/11' it's just cotton wool, but it's too clear. In Gursky's 'Rhein II' image, you have transparent paper hanging in front of the cotton wool to make it softer, but it's only one layer. After a while we started to work with more than one layer....

AS: And here the water is made out of plastic foil. Today we have several methods to simulate water differently. We have silicone, we have epoxy, even sugar you can melt, and wax for the hair, lacquer painting.... We have to find, for every image, the right material.

WE: In the case of the tsunami, this would be cotton wool?

AS: This is cotton wool with epoxy.

WE: And what is the brown material?

AS: It's a little bit of spray colour and epoxy.... The palm trees are made out of feathers.

JC: Sometimes we also take objects which we can buy already finished.

AS: Like a plastic toy or model.

JC: But sometimes you can't really get this stuff, and then we have to build it. It always depends on how the object really looks. Sometimes it looks too cheap, and then we have to build it.

WE: Coming back to choosing, or not choosing, a subject. Are some subjects dismissed very quickly?

AS: At the beginning it was really clear which images we wanted to do. We also work with books, where all these images are, and then we just go through the book and say, 'OK, this one, that one.' Right now it's harder to select, because we've already done the most famous images. I mean, there are still some, but maybe they're too hard to do.

AS: But in a way we go deeper and deeper, and therefore more and more iconic images appear.

WE: And how long do you work on a picture? Do you always do one followed by another, or do you maybe work on two or three at the same time? And do you give yourselves a deadline, or do you just take the time?

AS: Normally we work only on one set, because even if the parts of the image, like the *Titanic* ship, are quite small, the depth of the set you see is very big. It takes up the whole studio, nearly.... The 'Exxon Valdez' is around 7 metres [23 ft] deep, and at the front about 1.5 metres [5 ft] wide. So there's only space for one set at a time. And also, for us, to concentrate on one set is better than two sets. It normally takes about three weeks. Of course, we have several other things to do, so sometimes, if we're busy, the set can stand still for two to three months. Ansel Adams [Making of 'Moon and Half Dome'] was three or four months in the studio.

JC: If you're working on the rocks of Ansel Adams, you could do that for much longer....

WE: So you can get a bit obsessed by details?

JC & AS: Yes.

WE: When you're finished, would you take the picture that day, or would you say, 'Let's wait till tomorrow'?

JC: We probably take a picture and then we sleep on it. Maybe when we've finished the image on a Friday, we have the weekend, and the next week we see what's working, or if there are details which are not quite right.

WE: And do you destroy the sets afterwards, or can you use parts of them again?

AS: We normally keep a 'trophy' – a piece of each. And all the materials or parts which are not very important or very clear, we try to recycle in a new image.

WE: But I would imagine not many things can be recycled as they are....
So, in the case of keeping things until the last minute, do you keep them until you're absolutely sure that your digital material is secure?

AS: Yes, we keep them until we do the little post-production touches, and then we check the image, the details, until we're absolutely sure that it's OK.

WE: Have you ever had to go back and photograph for a technical reason?

AS: Yes, when we did the Black Power salute, we changed to portrait format because landscape didn't work as well.... For each new image, we make nearly a thousand full-resolution digital images. We build the image in front of the camera, and at the beginning there are very big changes, but after five hundred images we're at the point where we're nearly perfect – the changes are so small that you probably wouldn't be able to see any significant difference.

JC: So we have the original image on the computer, and we can do an overlay to compare the original image with ours, and then we make an image, and then we make a change on the setup, and then after a while we make an image again, so at the end we have many, many images of the setup.... Like a movie, where you see how the thing takes shape.

WE: Do you ever exhibit that video?

JC: We have, but we don't see it as an artwork. I know it's really interesting for people to look at it, but for us it's just a documentation of our work.

WE: What everyone wants to know is: why don't you use Photoshop?

JC: Because we like to do it by hand. It's a challenge for us. We have the skill to do it in Photoshop, but we like to see it in our studio. And as we are showing all the tools and materials that we used to reconstruct the image by hand, for us this makes it reasonable not to use Photoshop but rather our hands.

WE: Is there any computer manipulation in the making of the picture?

AS: Not usually, but if we've shot an image and we have a detail that we liked more at the earlier stage than at the end, and we already moved the setup away, then we edit it in. We're not so idealistic that we say 'no Photoshop ever'. Normally we like to do a little colour correction and retouching, but, yes, we want to see it in our studio.

WE: Are you interested in theories of perception; the dilemma of reality and illusion?

JC: For our diploma project we did a work about places showing the illusion of something – so, yes, we are really interested in this topic.

WE: But it's not an academic thing for you? It doesn't start from theory....

AS: No.

WE: When it comes to the public, and they come and they see and they talk to you, do you understand what they're looking at?

JC: Sometimes we're surprised that they don't understand it. People look really quickly at images because there are so many of them, but if you look at some of our images that way you may think, 'Oh, it's Photoshop'.

AS: I hear a lot of people who don't understand our images – who don't look at photographs closely – if they're in an exhibition; they say, 'Yes' or 'No', but they don't think about it. It's not an active viewing of something.

WE: Marshall McLuhan had a great phrase. He said modern viewing is pattern recognition. So people just walk in, they try to grasp basic concepts, 'OK, colour photographs, big colour photographs, iconic pictures, seem to recognize them, fabricated...', and that's it, for most people. Very few people are going to look carefully ... but some do.

AS: They come and see, and they think, 'Oh, it's the *Titanic*, yes ... but why...?' We want to activate the viewer; to push them to think about our photographs, and think about the original.

WE: It takes a minute. I mean, if I were just to walk in, I'd see this photograph, I'd think, 'Is that just a photograph, a blow-up of a photograph, I've seen many times before?' But then you notice details that start to question that, and then you start to question what you're seeing as a whole. You're playing with people's perceptions there.

AS & JC: Yes.

JC: But another funny thing is that we've also had questions from people who've said, 'I like your "Making of…".' The title was 'Making of…', and they came to it to see the final image, you know. But they think this is just the 'making of' – in other words, it's not finished yet – and the final image will follow….

WE: You're touching on so many things here. We're used to thinking of photographs as sealed records of the past, and then somehow you're bringing it back to life, so you're kind of suggesting that it's actually happening now, in a way. By refabricating it, you're bringing it back, watching again….

JC: Yes, it's a moment; a moment of time.

AS: But when we're setting it up, it's not a moment any more, it's staged, and the surroundings seem like the documentation of our setup – the scattered tools and materials that look like a documentation of a normal day of work in our studio; and when you look outside the studio windows you see the weather conditions, which are a very clear statement of being 'at this time'.

WE: But it still seems to be happening, and this is so effective. I would think some people would think – when looking at the wall of water for the tsunami, for example – 'Oh, they have some kind of pump' that actually is pouring out, you know; you have the feeling that in a second it'll come forward…. And also there are two kinds of pictures. You have pictures where the event is visually striking – like Concorde, or the World Trade Center, or the jets colliding – and it's a very momentary, almost split-second thing; whereas with the *Titanic* sailing away, the historic event hasn't happened yet…. The sister ship was the *Majestic*, and it never sank, it went on many years' faithful service. So, if you said, 'This is the *Majestic*', it would change everything, because … nothing of great significance ever happened. It's because we know what happened that the image punches us in the gut…. With some pictures – like the Black Power salute – we have to bring some history to it. Could we take one photograph and talk about it in detail?

AS: Man on the moon. We're selecting this because it's a very famous image … and it's a very simple image, just a little bit of dust or sand, nothing else.

WE: And how long would you have taken for this photograph?

AS: I would say two weeks. The first problem was to find the right material to simulate the surface of the moon. We tried it with sand, with flour and different things, and finally arrived at cement powder.

WE: And there's the photograph. Is that the original?

AS: Yes, in a lot of our images you will see the printed-out original photograph.

WE: So, why did it take two weeks?

JC: The problem is the details. The real problem was to be satisfied with this footprint, because we'd built this piece of wood that simulates the boot, and you have to do the print in one go. And we didn't manipulate the footprint; we really did that many, many, many times before we got it right.

WE: This dust goes everywhere too, huh?

JC: Yeah.

AS: It's also very dangerous.

JC: The material is perfect for the image, but it's really fragile, so….

WE: So in a case like this, you're touching on another subject, which is the conspiracy theory about how this never happened. How do you feel about entering that zone?

JC: We have images where it's obviously staged or maybe faked, like we have 'Nessie', that's proved to be fake.

WE: That's not true, is it? I still believe in the Loch Ness Monster!

AS: A question we also sometimes get asked is if we believe in the hoax. But for us this work is not about the hoax.

JC: If a magazine wants to reprint an image in the context of conspiracy theories, we always reject it.

WE: But what's interesting is we get trapped in situations we don't intend. This crazy conspiracy thing is very real. A photograph like this could escape

your control. You could find it on the internet as supposed proof that it was all fabricated. You don't get any credit, it's just an image … and it's tweeted or Instagrammed or whatever, and suddenly it's all over the place. 'Hoax, hoax!' So in a way, what you're doing, with no intention, is you're exposing yourselves to this kind of doubting; a cultural moment where people are dealing with photographs constantly in their lives, like never before … as you say, not looking, really. Everything is taken out of context. It can be removed, somebody can see this, snap it, snap it in the exhibition, and say, 'Hey guys, look, proof!' Have you ever thought about that – that kind of misuse of your photographs – as an issue?

JC: For me, no. I don't think our images are perfect enough.

AS: It hasn't concerned us, but we want to have control over the context where an image is used, because the use and the context of the image were and still are very important. I think now, in the era of fake news – it's probably the first year or the second year of this big important phrase – it's good for us, for our work, that people are concerned about the truth of photography and what truth someone wants to tell with photography.

WE: Your work really does get at this question of truth. You're exposing photography in a way. You're kind of opening it up….

AS: I think if you say photography shows the truth, you will always find photography that can support a conspiracy theory, because photography is only one part of the world at one time; it's not showing everything.

WE: Yeah, sure, it's a kind of dilemma. We're never going to escape from subjective view. But your work really does force people to think about these things … though it's your love of photography that really does it; it's not theory-driven.

AS & JC: No.

WE: Do you feel that what you're doing is on a continuing path, or can you imagine coming to a definite end?

JC: History is still going on, there are more and more images, but at some point it's not interesting any more.

WE: For you?

JC: For us. For people, I don't know, maybe it's still interesting. We still have some images that we're interested in doing, but at some point we'll come to an end.

WE: Assuming you'll find a new direction, how do you feel about the history of photography and your place in it? Do you feel more attached to, say, contemporary art or conceptual art, or, you know, classic photography? When I say classic, I don't necessarily mean Ansel Adams, but I mean *the* history: Winogrand, Friedlander, Arbus, even Gursky, the Bechers. Where do you situate yourselves in that map?

AS: I would say conceptual art. There are, as you said, a lot of photographers who have the theory and the concept first, but they are more academic, whereas we come from, I would say, a more visual, aesthetic direction.

JC: I think the concept in our work is really important partly because there are two of us.

WE: Are you complementary minds? Do you each have a certain strength, so that you compensate for each other's weakness?

AS: I would say that we're quite similar and some people even say, 'Are you brothers?' I wasn't surprised when you asked, 'Are you Adrian or Jojakim?' when we met.

JC: But we're also really different.

AS: I mean, if you are similar, you also know the differences very well.

WE: Coming back to the Robert Frank you're working on right now…. That's a kind of homage, no? Or not?

AS: Yes … but the whole series is a homage to all the photographers, including those who are not very famous and whose images are probably not as iconic as the others.

WE: Do you feel part of something, part of a community? It can give strength to an artist if he or she doesn't feel completely alone; if, you know, this has been going on for a long time, and people have been finding their own way, and then you maybe hear somebody talking and you realize they didn't always have a good time of it; there was a mental block, a fallow period. I'm always interested in this community. And in the past, artists didn't really think about anything outside: the Swiss photographers were only concerned about having their exhibitions in Switzerland, the French were only concerned about having their exhibitions in France, and the British in Britain…. It was really like that, years ago when I started, and of course if you offered them something outside they were thrilled, but it wasn't their frame of reference. But now the frame of reference for most people

is the world, basically, or the industrialized world, and you're just as likely to see something on the internet, and you don't care who the person is or where they live if the work interests you. You read that this guy, he's a Chilean photographer, or a Brazilian photographer, but it doesn't make any difference, so that's what I'm asking. For your generation, out of art school for a little more than a decade, how are you seeing your world of photography at this moment and in the near future? Are you feeling positive about it? Do you feel positive about possibilities, you know, earning a living and....

JC: Yes, right now we see it positively, but we didn't have a strategy to cross borders, we didn't really plan. At some point you kind of lose control of the work. I mean, when you publish your images on an internet site, then you're losing control of it. At first we were a little bit scared, as you didn't have the control, but then we kind of accepted it.... I mean, it's our aim not to stay in Switzerland with this work ... but we are also a little bit lucky. There are many good artists in Switzerland who might not have the luck we are having right now.

WE: Yes, nobody really wants to talk about the future more than two years or off. But artists have the additional pressure of having to come up with something new.

JC: Especially with this work, which has been very successful – that puts us under pressure to get something new.

WE: You have to remember Bob Dylan going electric, and almost everybody hating him for it! It has to feel right. You don't move because you feel you should move. You move to something new because you feel it's the right moment to do that.

JC: I think we could keep doing it, but at the end of the day it has to be OK for us.

WE: Yes, it does. And the other thing is, once you finish a body of work, it gets better with time. It's like putting wine down; it gets better. So it might be, in terms of creative juices, dead for you, it's finished, but it actually has a life of its own, gets more interesting with time.

AS: But it's only a small percentage of the wine and the photographers that remain.

WE: Yes, but if the work is good – because there's a lot of mediocre work; it's OK, it's fine, but it's not special.... But the work that's really interesting will always look interesting. Like Cartier-Bresson, Man Ray, Berenice Abbott, all that stuff that you know is not going to lose its interest, it only accumulates its interest, it comes back over and over again. So, as long as the work is good and original, it becomes more interesting. So that's something to build on always.

AS: Yes, those famous photographers, they are timeless in one way, but in another way they are representing their time.

WE: That's right, yes, and that's why we turn to them. And it's interesting, there's a site online called coveringphotography.com, and it's just covers of books collected by an American photographer, Karl Baden. He's collected 6,000 books now, or something like that number, all with covers bearing famous photographs. I'm not talking about photography books per se, but novels, books of poetry, non-fiction, etc. And what's so interesting is the photographers who are being used the most – legally, but sometimes illegally, without permission – are Berenice Abbott, Walker Evans, Man Ray, Bill Brandt, August Sander, Edward Weston. And they are not the contemporary celebrity photographers, not the hip younger photographers, not the fashionable names. It's amazing, the classics keep coming back. I just saw, in the bookstore in Geneva, an Edward Steichen on the cover of a modern romance novel. It was a black-and-white photograph, it had been coloured, and on the back it didn't even credit him, just the agency.... [Laughter] But I recognized who it was, and that's not bad for somebody who made the photograph in 1930. So it still speaks, that's what I'm saying, it still speaks. And that's what's interesting about history: it moves, it adds new things while others fade – some of those things become less interesting, and some of them become more interesting. As the cliché goes, 'Time will tell'. So you have to just keep working – that's the whole thing, to keep working. Artists, if they stop working ... well, everyone else loses interest fast. I'm glad to hear that you guys haven't finished yet!

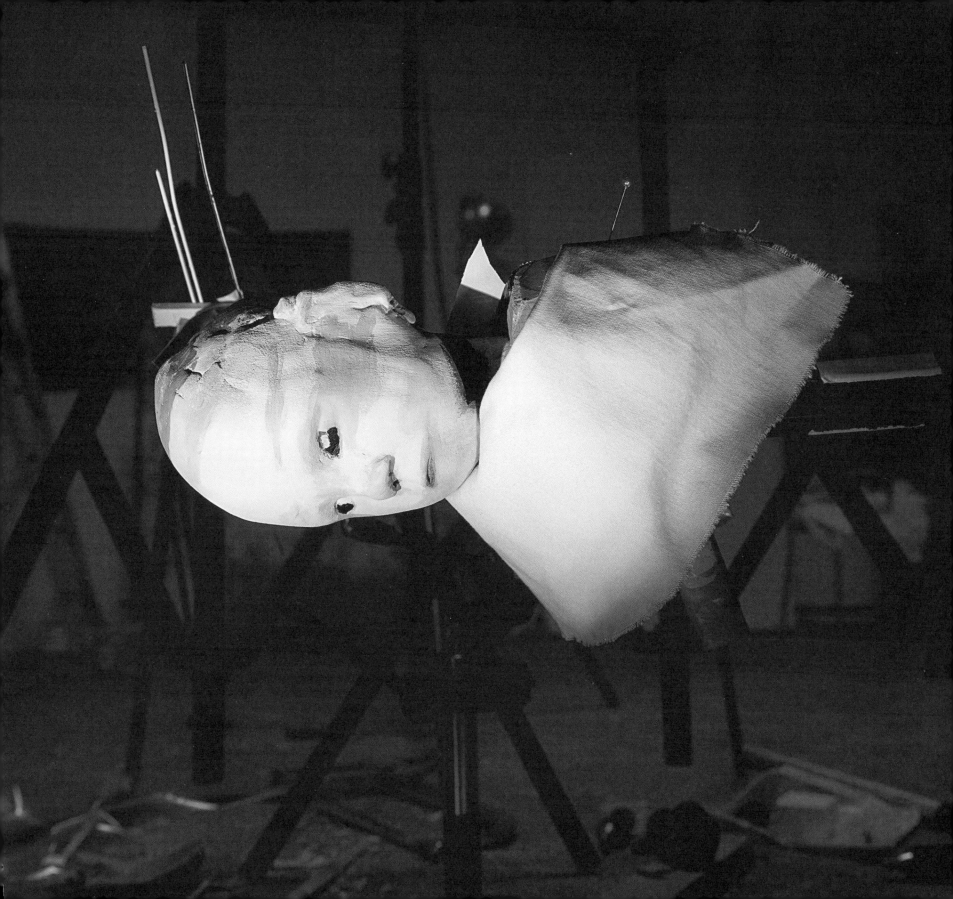

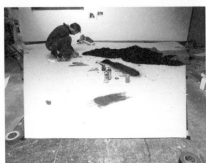
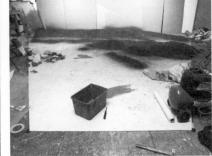
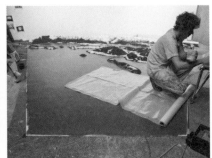

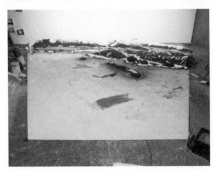
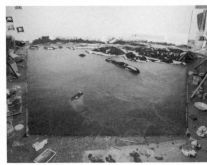

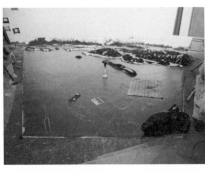

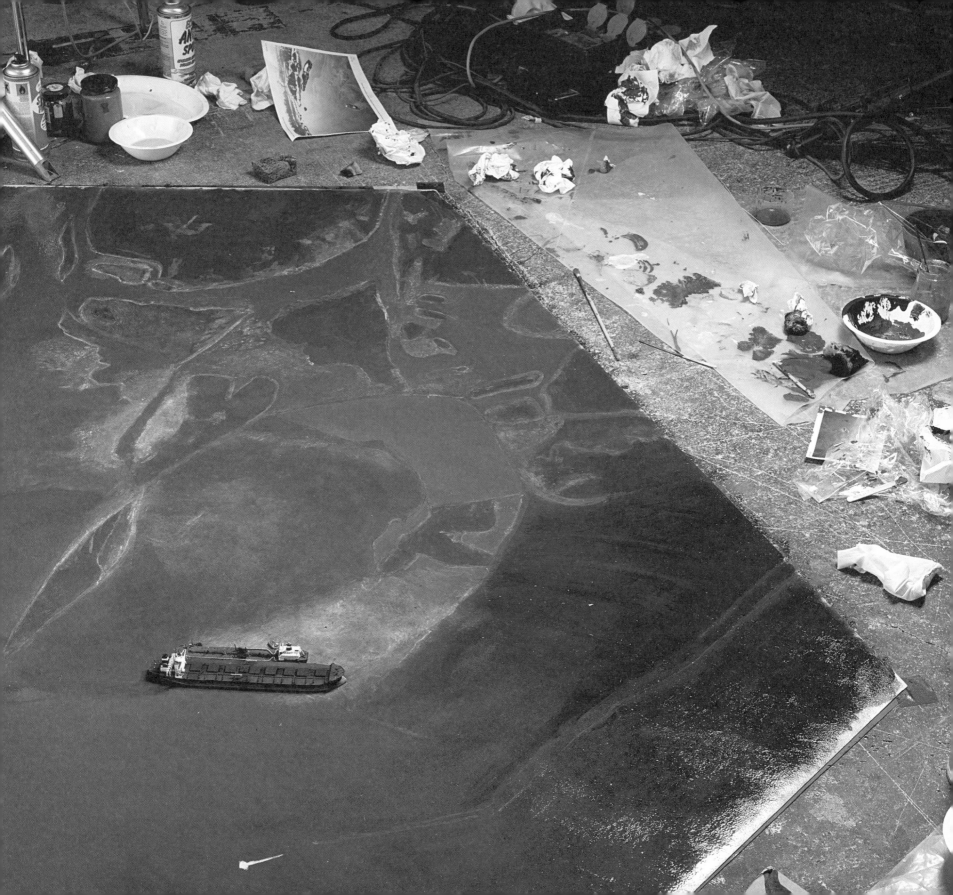

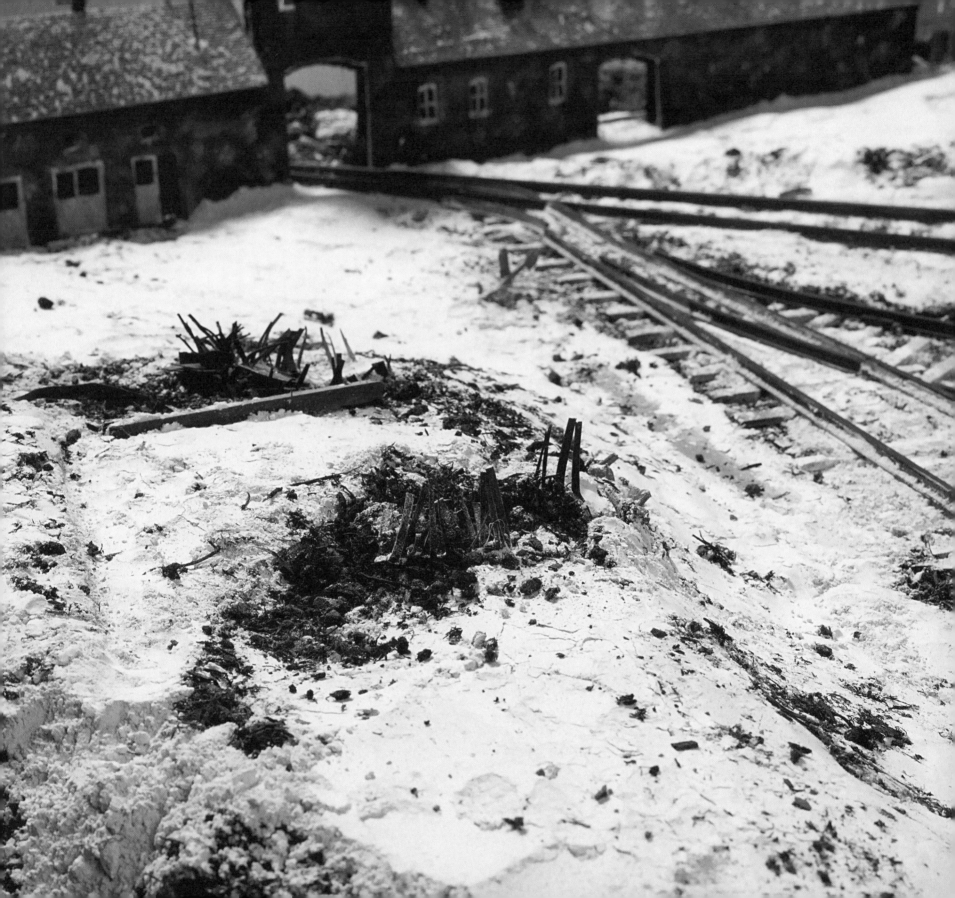

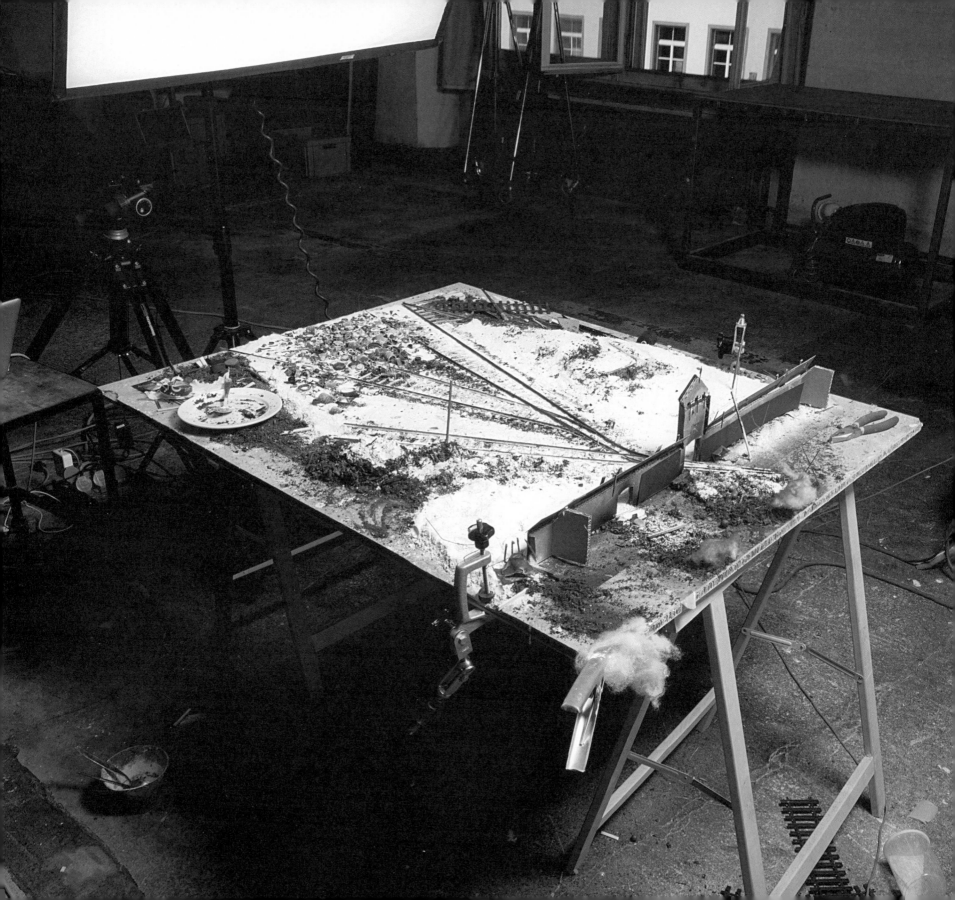

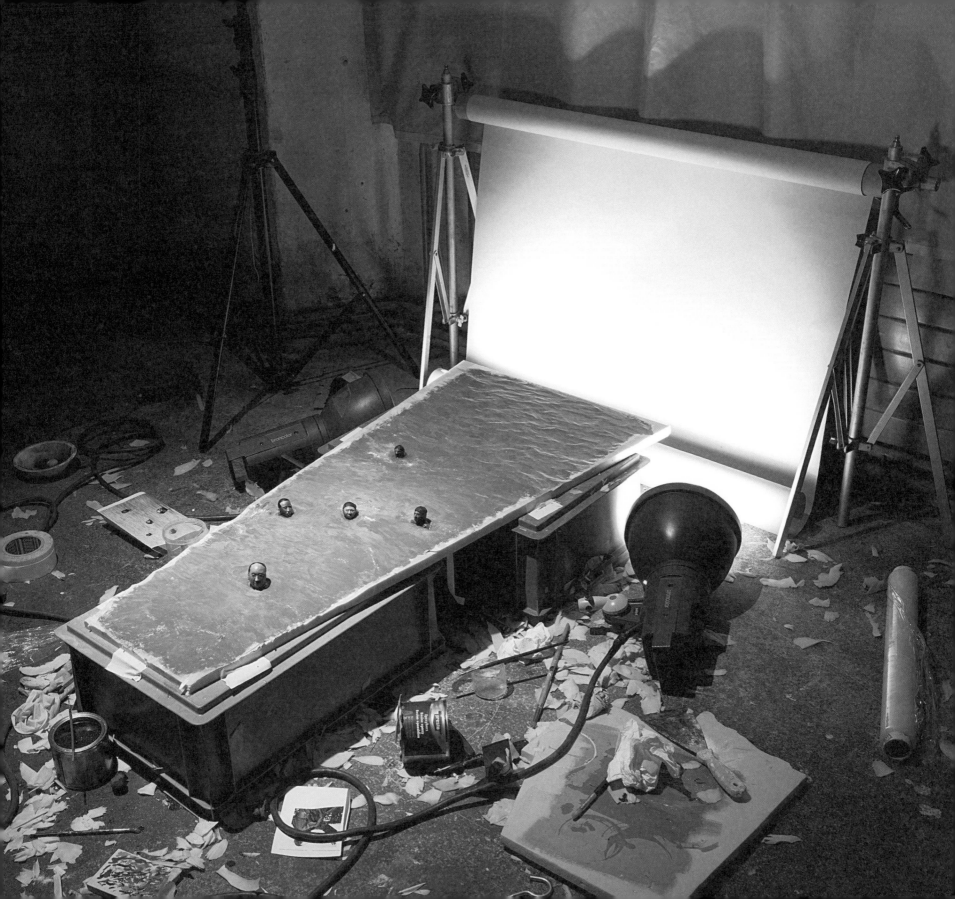

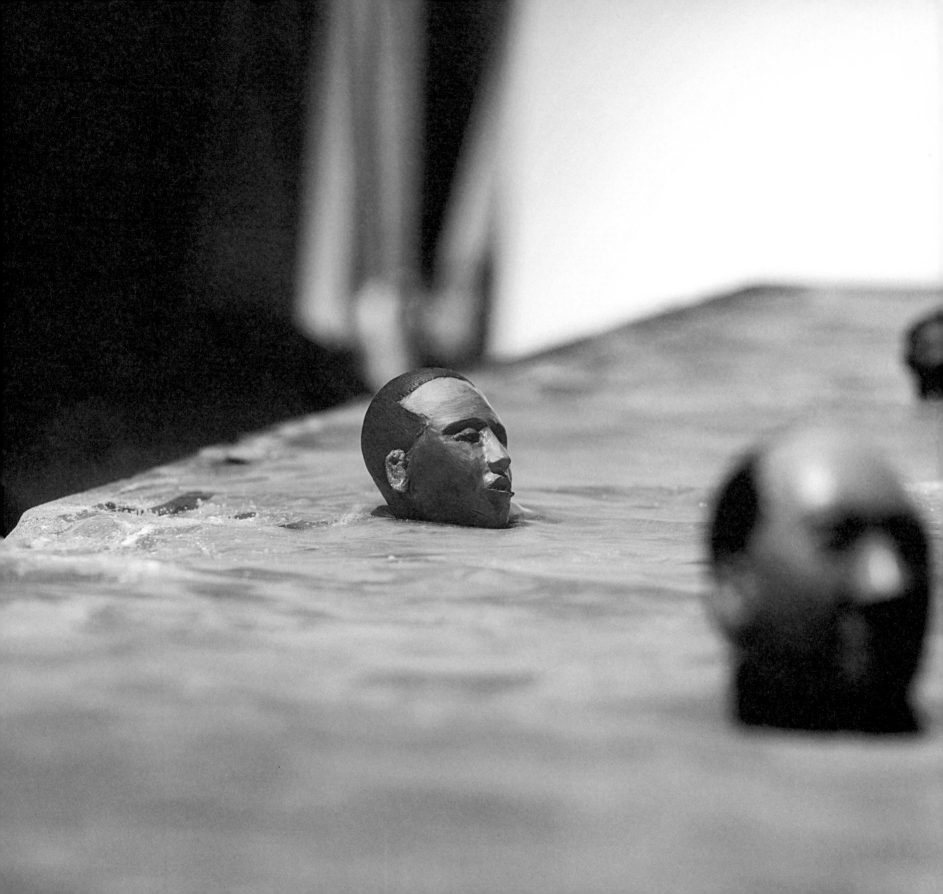

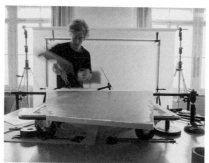
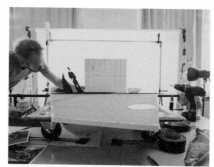
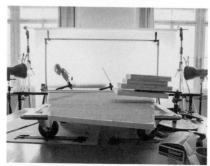
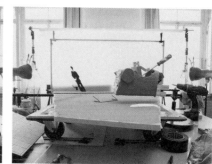

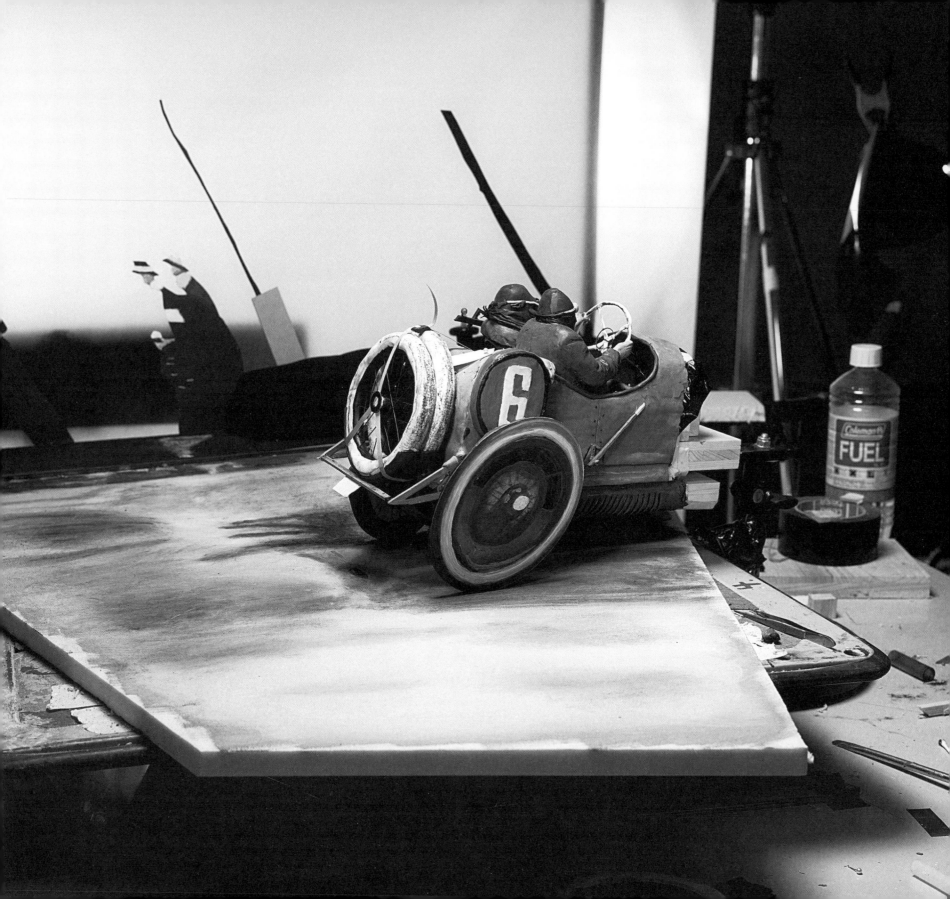

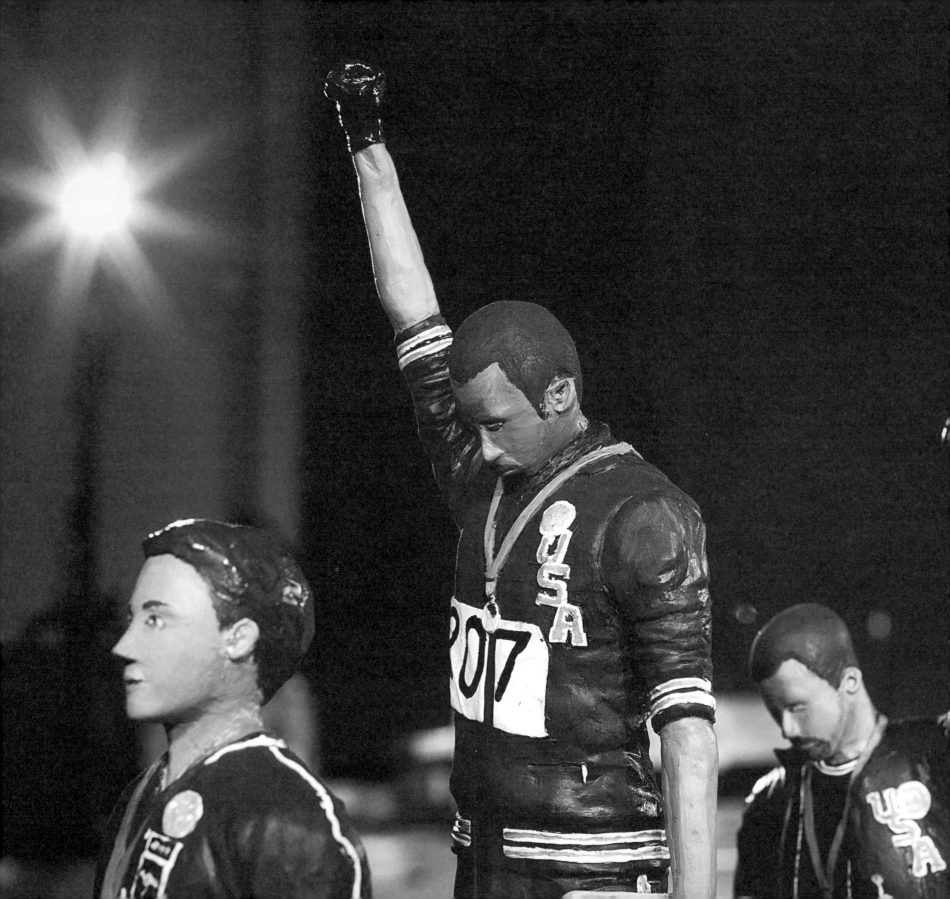

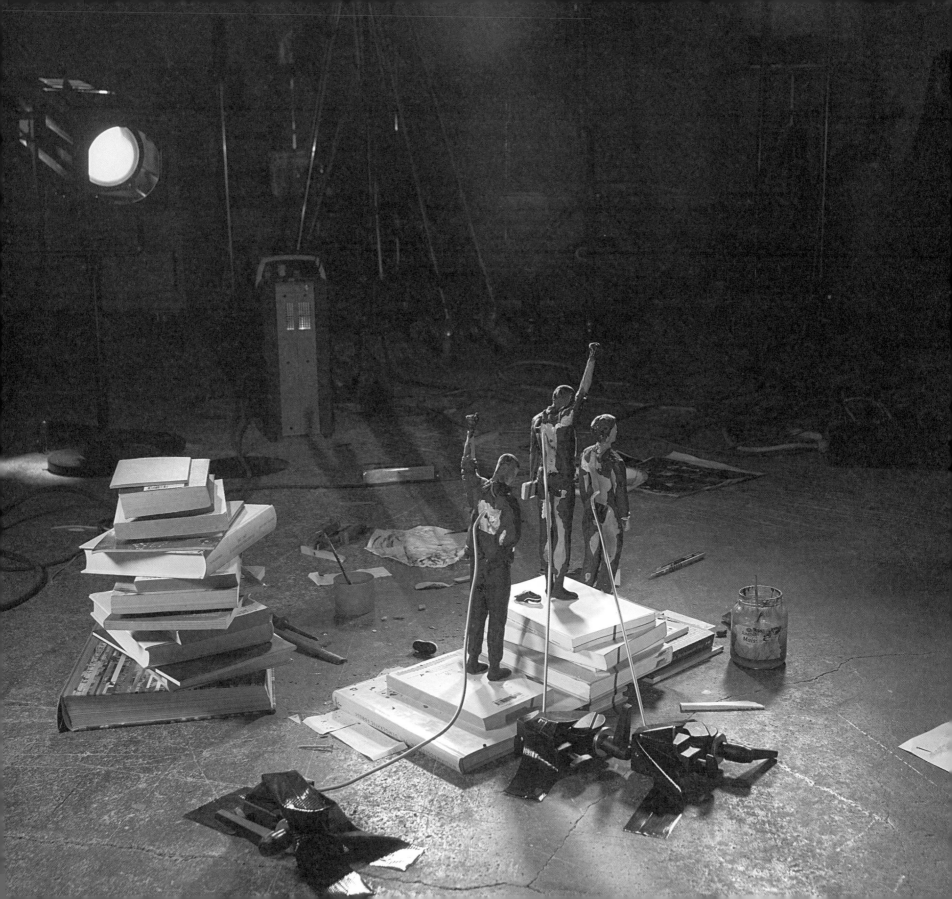

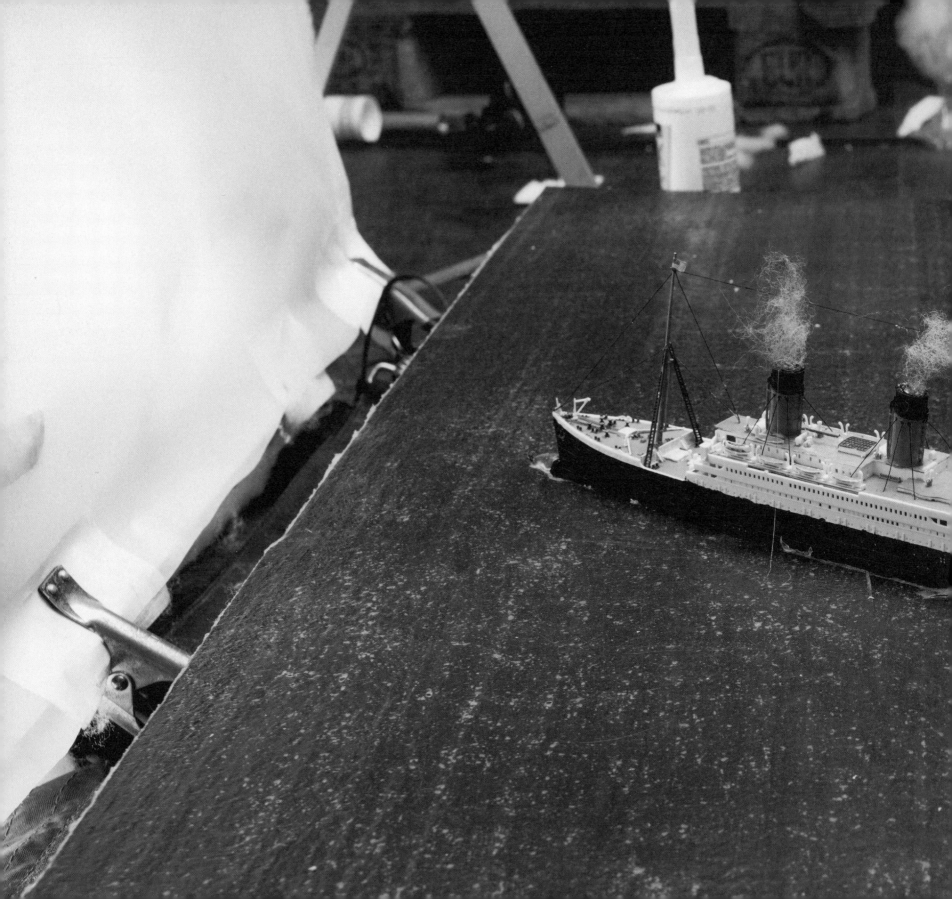

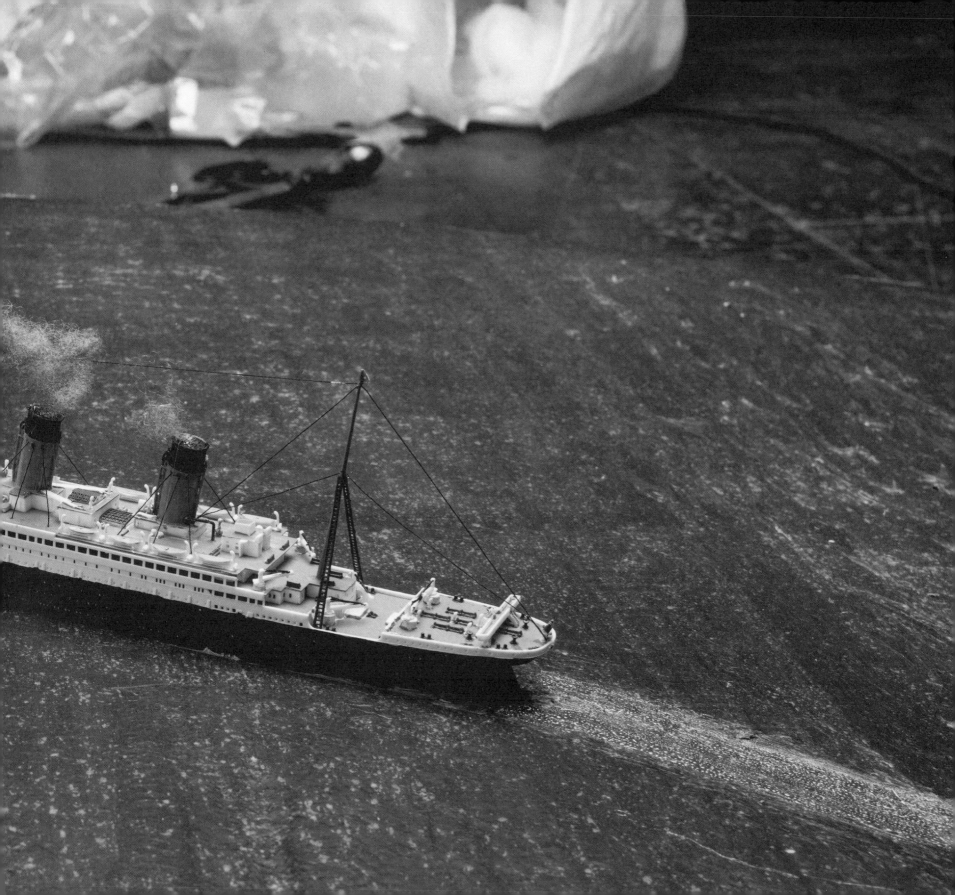

THE MODELS IN THIS BOOK ARE RECONSTRUCTIONS OF 39 ICONIC PHOTOGRAPHS FROM THE HISTORY OF PHOTOGRAPHY, CREATED AND PHOTOGRAPHED BY JOJAKIM CORTIS AND ADRIAN SONDEREGGER. THANKS TO THESE FABULOUS PHOTOGRAPHS, OUR WORK HAS BEEN ABLE TO EXIST. WE HAVE TRIED TO CONTACT ALL PHOTOGRAPHERS AND COPYRIGHT OWNERS TO EXPLAIN THE BACKGROUND OF THIS PROJECT. EACH IMAGE WE RECONSTRUCT IS ALWAYS ACCOMPANIED BY THE NAME OF THE PHOTOGRAPHER, THE TITLE AND THE YEAR OF CREATION OF THE ORIGINAL PHOTOGRAPH.

ACKNOWLEDGMENTS

Thanks to:
Andrew Sanigar
Sam Palfreyman
Martin Andersen
Christian Caujolle
Florian Ebner
William A. Ewing

Our families:
Yvonne, Juri and Sascha Meier;
Marlies and Jakob Sonderegger;
Silvia Ercolani, Naël and Levin Cortis;
Jane and Günter Cortis

And to:
Elie Domit
Peggy Sue Amison
Lars Willumeit
Jörg Brockmann
Ruth Eichhorn
Bryce Wolkowitz
Aline Aumont
Fritz Franz Vogel
Diego Bontognali
Valeria Bonin
Simon Haas
Taiyo Onorato
Niklaus Rüegg
Pierre Schauwecker
Jules Spinatsch
Andreas Wilhelm
Esther & Miles Butterworth
Nicolas Vermot Petit-Outhenin
Andrea Berclaz
Faustino Garcia

In addition, the publisher and the photographers wish to
acknowledge Peter Pfrunder and the Swiss Foundation of
Photography, Winterhur, for their support and exhibition
of this project.